Botticelli

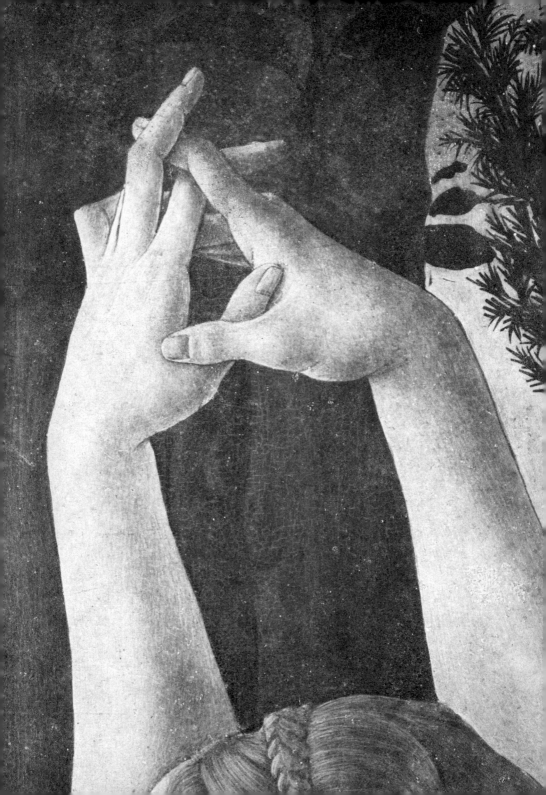

Botticelli

L.D. AND HELEN S. ETTLINGER

138 illustrations
18 in colour

NEW YORK
OXFORD UNIVERSITY PRESS
1977

For our Nancy

Frontispiece

1 Hands of the Graces, detail from the *Primavera*

Library of Congress Catalogue Card Number: 76-26747

Printed in Great Britain by Jarrold and Sons Ltd, Norwich

Contents

Preface

THIS SHORT STUDY is intended to introduce the art of Botticelli to the reader and make him aware of some of the problems that exist. We have not made a list of all acceptable paintings and drawings by the master, and the fact that a particular work is not mentioned does not mean that we reject it. We have only selected those paintings and drawings which seem to us most significant and before writing our text we have endeavoured to see every one in the original.

Nor have we tried to write a comprehensive monograph on Botticelli. Neither the present moment nor the format of the World of Art series allow such a task. Much of Botticelli's work is badly in need of re-examination to separate the wheat from the chaff. As we learn more of the social structure of Florence during the second half of the fifteenth century, of patronage, and of the political situation and the true impact of Savonarola, Botticelli's place must be redefined in the context of his time.

The literature on Botticelli is vast and multilingual. Without the incomparable resources of the Kunsthistorisches Institut in Florence – both in books and photographs – our task could never have been completed.

L.D.E.

H.S.E.

Florence, 18 September 1975

Life

BOTTICELLI WAS BORN Sandro Filipepi, the youngest son of the tanner Mariano Filipepi of Florence, about the year 1444. Although there is no record of the actual birthdate we know from the father's tax returns that in 1447 he declared his son Sandro to be two years old and in 1458 Sandro's age is given as thirteen. The nickname 'Il Botticello', meaning 'Little Barrel' belonged originally to Sandro's eldest brother, Giovanni, apparently due to an unfortunate resemblance. This appellation was transferred to the youngest brother by, at the latest, 1470, when we have the first document referring to 'Sandro Mariano Botticello'. By the time of Sandro's death 'Botticelli' had become the family surname.

The Florence of Botticelli's youth was a city alive with artistic creation and international business and politics. Since Florence was bigger than most Italian cities and had a large and active merchant class she was in a position of great influence not just in Italian affairs but also in Europe as a whole. Her wool, imported raw from England and woven in the city, and her silk products were in tremendous demand all over northern Europe; her bankers had branches in every major European centre and dealt with kings and princes. The internal stability of the city created by the firm guidance of the Medici in city politics sustained a period of artistic creativity which produced many of the greatest works of the age. This prosperity reached its peak under the leadership of Cosimo de' Medici who returned from exile in 1434 and never again relinquished power until his death in 1464. By that time a financial decline had begun and with the death of Cosimo's grandson, Lorenzo il Magnifico, in 1492, the 'golden age' of Florence and the Medici was past. But the period of Lorenzo's rule was also that in which

7

Botticelli became the most popular and most widely imitated artist in Florence. In the whole of the Quattrocento there is no artist who had such a wide following and, as a result, so many attributed works.

Sandro, like so many Florentine painters of the fifteenth century, came from the artisan class, but little is known about his education and training. Mariano's tax return of 1458 claims his son is in poor health and, rather puzzlingly, also states that Sandro '. . . sta allegare', a phrase which has lead to a lot of speculation by historians. Some have thought it meant that he was 'learning to read', but this would be somewhat unusual for a boy of thirteen, while others have interpreted the phrase as meaning he is learning to 'set or mount', that is, jewels in precious metals, which is a more likely explanation, as it was not unusual for Florentine artists to serve an apprenticeship with a goldsmith. Vasari (whose *Lives of the Painters, Sculptors and Architects*, first published in 1550, is our most important single source for Italian Renaissance art) explicitly states that Sandro was apprenticed to a goldsmith, and Sandro's second brother, Antonio, was a *battiloro* or 'beater' – a journeyman metal-worker who beat out the metal before it was fashioned by a master – so the young artist certainly had a connection with the craft.

But goldsmith work was not for Sandro. Vasari and others tell us that he became enamoured of painting and was subsequently placed by his father in the workshop of Filippo Lippi. This could have happened no later than 1460, as it was unusual for a boy much over fourteen or fifteen to be accepted as an apprentice. At this time Lippi was engaged on a fresco cycle in the cathedral of Prato and must have maintained a workshop there. The influences of this apprenticeship under Lippi remained with Sandro for his entire career, and Filippesque characteristics are still found in his work of 1500. After Filippo's death in 1469, his son Filippino came to Botticelli's workshop from which he emerged as Botticelli's most distinguished pupil.

Sandro's first documented commission came in 1470. Vasari writes: 'While still quite young he painted a figure of *Fortitude* in the Mercanzia in Florence, among those pictures of Virtues made by Antonio and Piero Pollaiuolo.' The Mercanzia, a commercial court made up of representatives of the principal guilds, had awarded the large commission of seven figures representing the Virtues, each on a separate panel, to Piero Pollaiuolo in 1469, after long and involved deliberations. These allegories, meant to instil their spirit into the judges, were to be hung in the Council Chamber. Piero was presumably still at work on them in 1470, when the commission for *Fortitude* was taken away from him and given to Botticelli. Just why Sandro suddenly received this honour is unknown, but there had been by no means unanimous consent over the original selection of Piero for the work.

In the next ten years Botticelli established his reputation in Florence, producing some of his finest works, such as the *Primavera* and *The Adoration of the Magi* for S. Maria Novella. Early in 1475 he was in Pisa to do a fresco of the *Assumption* for the cathedral, but this was never finished, presumably because the city fathers were not happy with the trial piece, and what had been done was destroyed in the sixteenth century. But in spite of the Pisans' disapproval Sandro continued to enhance his reputation by fine and innovative works in Florence and by 1480 he was busy and affluent enough to maintain a workshop of at least three assistants.

The Pazzi conspiracy of 1478 pushed Botticelli very much into the public eye. On 26 April, while High Mass was being celebrated in the cathedral, a group of conspirators under the auspices of the Pazzi family and with the blessing of Pope Sixtus IV attacked Lorenzo and Giuliano de' Medici. Giuliano was killed, but Lorenzo escaped wounded into the Sacristy. The Pazzi, who were the only serious rivals to the Medici at that time, tried to foment a rebellion against the Medici upon learning that their assassination attempt had failed, but the people rallied behind the Medici and that same evening the

conspirators who had been captured were summarily hanged. It was the custom in Florence to paint on public buildings the effigies of traitors – the executed shown hanged, the imprisoned hanging by their feet – to publicize the punishment and to serve as a constant reminder of their fate. Botticelli was now ordered to carry out this macabre task. Although the commission was paid by the 'Signori Otto', that is, the city government, the Medici must certainly have been consulted on the choice of the artist. The great importance of this commission, the publicity of the conspiracy and the eminence of the Medici must have made this a particularly desirable assignment, and it shows the prominence of Botticelli at the time that he was selected for it. At this time the power of the Medici was such that even the Archbishop of Pisa, who had played a prominent role in the conspiracy and was hanged for his efforts, was depicted with the other traitors over the door of the Bargello, despite the protests of and embarrassment to Pope Sixtus. These effigies remained until the expulsion of the Medici from Florence in 1494 when the exiled Pazzi returned and had them destroyed. The figure of the Archbishop had already been removed in 1479 after long, involved negotiations between the Pope and the Medici.

 The year 1481 brought a great honour to Botticelli. He had been engaged the previous year in painting a fresco of 15 *St Augustine* for his parish church of Ognissanti, a work commissioned by the Vespucci family, who at the same time commissioned Domenico Ghirlandaio to do a corresponding *St* 13 *Jerome* on the opposite wall. This was the first of several times that these two artists would be asked to work together. But now these two Florentines, together with Cosimo Rosselli and Pietro Perugino, received their most prestigious commission. They were summoned to Rome by Pope Sixtus to decorate the newly built Sistine Chapel in the Vatican Palace.

 The decoration of the Sistine Chapel was a monumental and intricate task. Not only was there a complex iconographic programme to be followed, but the compositions by the various artists had to be coordinated. Perugino was placed in

10

charge of the work as a whole while each artist was responsible for all the decoration in each of the bays to which he had been assigned, from the painted curtains on floor level to the portraits of the popes in the clerestory. Contrary to Vasari's claim, Botticelli was not directing the whole undertaking but was only assigned three frescoes: *The Youth of Moses*, *The Punishment of Corah*, and *The Temptation of Christ*. In spite of the enormous amount of work this commission required, Botticelli and Ghirlandaio were back in Florence by the autumn of 1482. 30, 31, 34

The early 1480s saw many significant changes in the artistic climate of Florence. By the time of Botticelli's return in 1482, Leonardo da Vinci had left for Milan. Two years later Antonio and Piero Pollaiuolo went to Rome for the construction of the tomb of Sixtus IV, and in 1485, Andrea Verrocchio was called to Venice for the Colleoni monument. None of these latter artists ever returned to Florence, Verrocchio dying in 1488 in Venice and the Pollaiuoli remaining in Rome until their deaths in the 1490s. Before the return of Leonardo in 1500 there were therefore few artists to rival Botticelli in Florence. His style had matured during his sojourn in Rome and the honour of a papal commission had enhanced his prestige. He was commissioned to take part in the decorations of the Sala dei Gigli of the Palazzo Vecchio (which were never carried through) and worked for Lorenzo il Magnifico in his villa of Spedalletto near Volterra. Not only was Botticelli engaged with many important private and public commissions, but his formula for paintings of the Madonna and Child was in great demand and being reproduced in massive quantities by his workshop and imitators.

An interesting document gives ample evidence of the high esteem in which Botticelli was held during this period. At an uncertain date, probably during the late 1480s, Lodovico il Moro, Duke of Milan, decided to have the monastery of Certosa di Pavia decorated with frescoes. With this in mind he obtained from his agent in Florence an account of the most prominent painters of that city. Sandro Botticelli is named in the first place, described as 'A most excellent painter, both on

panel and wall. His works have a virile air and are done with the best judgment and perfect proportion.' Filippino follows in the second place: the Duke is informed that he is a pupil of Botticelli and son of a famous painter. His works have a 'sweeter air' than Botticelli's but not as much skill. Perugino is called an exceptional fresco-painter and Ghirlandaio a good panel-painter but, the agent claims, he is better with frescoes. In conclusion Lodovico's correspondent tells his employer that these masters have worked at Spedalletto for il Magnifico and that 'the palm of victory is much in doubt'. But praise for Botticelli was not universal. Leonardo wrote that, because he did not study the painting of landscape for landscape's sake, Botticelli was 'vain', and, therefore, not a painter of the highest order.

In spite of the fact that he must have been earning a good deal of money in the 1480s, Sandro never moved out of the family residence. Although his father had died in 1482 during Sandro's absence in Rome and the house had been inherited by his brother Giovanni (who had a sizable family of his own), Sandro not only went back to live there on his return, but maintained his workshop on the same premises, an unusual practice at the time. Even after Giovanni's death in 1493, Sandro continued living with his nephews and indeed remained there until his death. In 1494, his brother Simone returned from Naples and also moved in. Soon after his return he and Sandro leased a farm with a villa outside the gates of Florence near Bellosguardo, but this was never any kind of permanent residence.

Perhaps it was a combination of personal reasons and the difficult political climate as well as a declining income that prevented Sandro from leaving the family residence after his brother had died. The death of Lorenzo il Magnifico in March 1492 brought the end of an era to Florence. Not only were there far fewer artistic commissions, but the death of Lorenzo precipitated the decline of the Medici bank. The reins of government had been handed to Lorenzo's politically inept son, Piero, who was unable to consolidate his position. In the two years between the death of il Magnifico and the invasion of

Charles VIII of France, there had been growing unrest in the city. Charles had announced his intention of claiming the kingdom of Naples on the grounds that he was the heir of the house of Anjou. But to reach Naples he had to pass through practically the whole length of Italy. When he moved south in autumn 1494, Piero, after first threatening to oppose him, lost his nerve and ceded the vital port of Pisa and other Florentine possessions to the French. These actions so enraged the populace that they expelled Piero and restored a popular government.

Adding to the turmoil of those uncertain times was the emergence of the fiery Prior of San Marco, Girolamo Savonarola. From the time that Charles VIII ascended to the throne, prophecies, particularly of an apocalyptic nature, had become very popular in both France and Italy, and while millennial prophecies were not new to the Florentines, the general uncertainty of the times combined with the force of Savonarola's rhetoric proved too heady a mixture. Savonarola was able to exert more influence than his rival prophets of doom through a combination of inflammatory pronouncements and shrewd politics. Although the arrival of Charles VIII in 1494 was anything but unexpected, Savonarola was able to interpret it as the divine wrath he had often said would befall Florence. After Piero had fled and Charles had camped outside the city, the citizens sent Savonarola to Charles in order to prevent the sacking of the city. This he successfully did, with the result that he was hailed as the saviour of Florence and her own special prophet. Charles went on his way to Naples which he entered the next year. Savonarola now became a sort of religious dictator. His message proclaimed the rebirth of freedom and the return of virtue, with Florence as the New Jerusalem after the cleansing of her sins. Part of this cleansing consisted of the public burnings of 'vanities', an idea which he had appropriated from one of his rivals, and such things as jewellery, cosmetics and precious clothes were burned, but there is no evidence that works of art were included. In the end, Savonarola's excess of zeal and his political machinations were his undoing.

13

Excommunication by Pope Alexander VI was followed by the collapse of his power-base within the city, and the Signoria, the ruling council of Florence, encouraged by the Pope and the friar's Florentine enemies, had him arrested. At his trial he was made to confess to being a false prophet and on 28 May 1498 he was hanged and burned with two of his followers in the Piazza della Signoria.

It is difficult to say how far Botticelli was drawn into the turmoil caused by Savonarola and his death. Vasari claimed that Sandro was a close follower of the friar's, and was so shaken by his death that he never touched a brush again. This claim is certainly untrue because the *Mystic Nativity* is dated by Botticelli's own hand, 'In the year 1500.' That his brother Simone was a *piagnone* (literally 'mourner', a nickname for the followers of Savonarola) is well known, but there is no such information about Sandro. There is a curious reference which connects Botticelli with the followers of Savonarola. Simone reports in his diary in November 1499 (eighteen months after the friar's death) that he and his friends are using Botticelli's workshop as a secret meeting-place for Savonarola sympathizers. However, since neither Simone nor Sandro had any legal claim on the house which was owned by their nephews, it is hard to imagine Simone bringing members of an outlawed and secret group into the family residence for meetings. Indeed, Botticelli subsequently worked for people who had been among the active enemies of Savonarola. The evidence, while not conclusive, seems to indicate that Botticelli took no active part in the Savonarola movement. It is a different question whether his art was affected by the unrest of the times.

Nevertheless, Botticelli continued to work. From June to August 1496 he was employed in painting a *St Francis* (destroyed in 1529) in a convent outside Florence and his last recorded work was in 1497 for the Medici in the villa of Castello. Although he was recommended to Isabella d'Este as a successor for Mantegna in 1502, the days of his glories were past and younger artists with new ideas, such as Raphael and

41

14

Michelangelo, were attracting attention. Only some small works can be attributed to his last ten years. Botticelli was buried on 17 May 1510, in the churchyard of Ognissanti with his family. Although his grave no longer exists, the *St Augustine* he painted for that church remains there as a fitting monument.

2 Armillary sphere and lectern, detail of *St Augustine* (pl. 15)

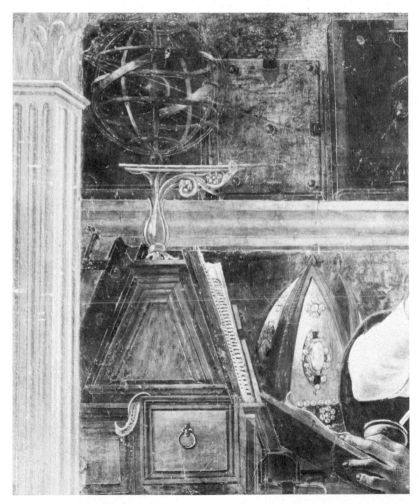

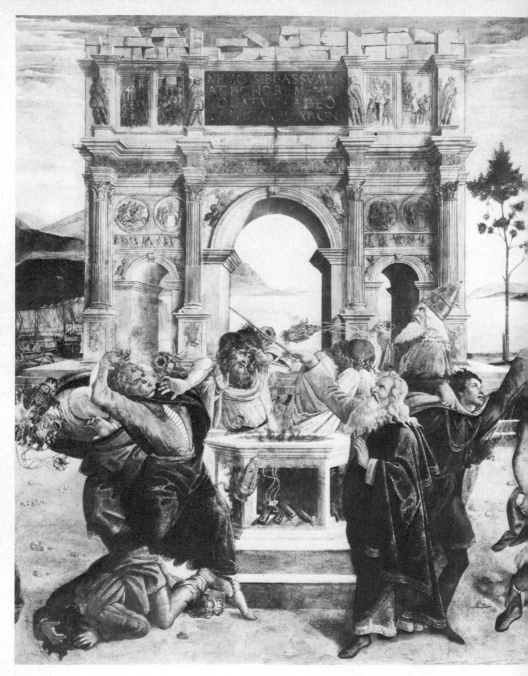

3 *The Punishment of Corah* (detail of pl. 31). Sistine Chapel, Rome

Religious Paintings

ALTHOUGH TODAY much of his fame rests on his celebrated 'mythologies', Botticelli, like every painter of his age, was primarily a painter of religious subjects. The few documents we have for his extant work are all connected with religious paintings and it is through these, together with a study of the evolution of his style, that we are able to establish dates for his major non-religious paintings.

The earliest document for a work of Botticelli's is the commission of 1470 for an allegorical figure of Fortitude. It is 6
obvious that an accomplished painting such as this could not have sprung full-grown from Botticelli, as Athena did from the head of Zeus, without a period of development and experimentation. But the always unclear waters surrounding an artist's beginning stages have been further muddied in the case of Botticelli by over-zealous dealers and collectors, all wanting 'a Botticelli'. Innumerable devotional paintings of the Madonna and Child were made in Florence during the Quattrocento, most of them mass-produced by workshops using as models works by popular masters. Since Botticelli's teacher, Filippo Lippi, appears to have been particularly well liked, there is a plethora of pictures with the superficial characteristics of the Filippesque pose and facial type. But it is impossible to say who, if anyone, in his workshop was actually responsible for these paintings. That this practice of mass-producing paintings continued throughout Botticelli's lifetime is demonstrated by an anecdote in Vasari which revolves round the fact that a *Madonna and Child* produced by the workshop and sold as a 'Botticelli' was actually painted by one of his assistants. Until an artist's style emerges from the workshop and takes on individual characteristics, no safe attribution can be

made. Furthermore, of all the varieties of religious paintings of the Quattrocento, the type that remained most unchanged and most uniform was the Madonna and Child.

There are two small panels (31 by 21cm) that can be safely attributed to the young Botticelli on more than just stylistic grounds. First mentioned as his work in 1584 by the Florentine historian Borghini, these panels showing the story of Judith formed part of the Grand Ducal collection which eventually became the state museum of the Uffizi. Thus, unlike many other Botticelli paintings, these have a known history since the sixteenth century.

The contrast between these two panels is striking. The depiction of the *Finding of the Body of Holofernes* is full of grisly horror. His headless body, blood gushing from the neck, is sprawled naked across the bed. The entourage reacts with vivid gestures, expressing shock and horror. Offsetting the shrill colours are the heavy curtains of the tent, making the picture airless and claustrophobic. The painting of *Judith and her Maid* on the other hand shows them moving through a pleasant sunlit landscape, returning to the Israelite camp. Judith, holding a sword and an olive branch, seems unconcerned with either her deed or with the full-scale battle in the background. The severed head of Holofernes, held high by the maid, offers a stark contrast to the smooth and serene features of the heroine.

How much Botticelli was still under the influence of Filippo Lippi when he painted these panels can be seen particularly in the facial types of the two women. Judith has the fine aristocratic head characteristic of Lippi Madonnas while the maid shows the heavier, flattened features Lippi used so often for the angels attending the Virgin. But the detailed anatomy displayed in the body of Holofernes comes from another source with which Botticelli had close contact at this time – Antonio Pollaiuolo.

When Botticelli received his commission in 1470 for the *Fortitude*, at least four of the other six Virtues (Faith, Hope, Charity, Temperance, Prudence and Justice) had been

18

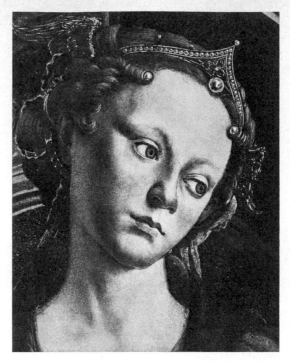

4 Head of *Fortitude*
(detail of pl. 6)

completed by Piero Pollaiuolo. In order to have his figure correspond to the rest of the series, Botticelli must have visited the workshop which the Pollaiuolo brothers probably shared, and there he would have seen work by Antonio. Although his interest in anatomy always remained no more than skin deep, Sandro must have been sufficiently impressed by the work of Antonio to experiment this once. That his interest waned very quickly is evident from the *St Sebastian* of 1474 which, while influenced by a Pollaiuolo model, is lacking in any detailed treatment of the human body. 8

Since Piero Pollaiuolo did not share his brother's enthusiasm for human anatomy, Botticelli had little difficulty in producing a painting in accordance with the rest of the series. Fortitude, like the other Virtues, is seated on a large marble throne, richly dressed and holding her attribute, a sceptre. The firm modelling and pose show how carefully Sandro had studied the companion paintings.

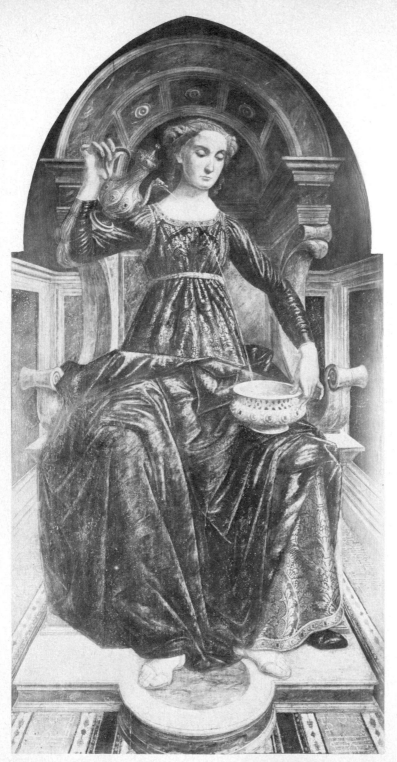

5 PIERO
POLLAIUOLO
Temperance

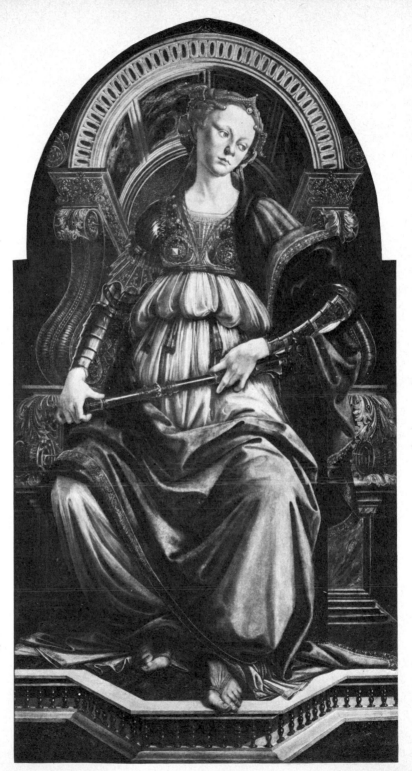

6 Fortitude

Still, this new panel is not a mere imitation of Piero's figures. Botticelli has given his *Fortitude* more volume and monumentality while at the same time treating the details with a delicacy and finesse lacking in Piero's handling. Once again the facial type, with the small pointed chin, tiny mouth and high forehead, as well as such decorative touches as the pearls in the hair come directly from Filippo Lippi.

One of our pre-Vasarian sources tells us that in 1474 Botticelli
8 painted a *St Sebastian* for the church of S. Maria Maggiore, now identified with the panel in Berlin. As a protector against the plague, St Sebastian was one of the most popular and, consequently, most often portrayed saints of the fifteenth century. About the time of Botticelli's painting Antonio Pollaiuolo was at work on his monumental altarpiece of the
7 *Martyrdom of St Sebastian* and Sandro must have seen it in the

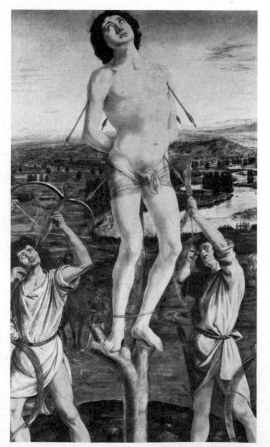

7 ANTONIO and PIERO POLLAIUOLO Detail of the *Martyrdom of St Sebastian*

workshop, as the similarity in the pose of the saint is too close to be purely coincidental. In both pictures Sebastian is placed high above the ground, tied to a tree-trunk, his feet resting on two sawn-off branches. But while Pollaiuolo expresses the anguish and pain which the saint suffers through the twisting of the body and upturned eyes, Botticelli has retreated from even the limited emotion depicted in the *Finding of the Body of Holofernes*. 10 There is no sign of suffering in the face, nor motion in the body. Instead, the body is carefully delineated and arranged in a strict contrapposto, the muscles becoming almost as decorative as the carefully draped and embroidered loin-cloth and the face appearing almost of chiselled fineness. This cold detachment contrasts rather strangely with the delicate warmth of the background, for once we look past the figure of the saint, the 9 mood changes. A tiny group of soldiers, having completed their deed, is returning to a delicately drawn castle on the edge of the water. One of them has stopped to rest, reclining on the grass, while another is shooting a bird. This little picture within a picture has its models in paintings from north of the Alps.

The great demand for Florentine textiles had led to close contacts between Florence and the cities of northern Europe. Florentine bankers established business houses in these centres, often with Italian managers, and for similar reasons merchants from the north would come south to supervise the purchase of goods. Commercial links generated artistic interests. Men from Flanders and the Netherlands bought Italian pictures, while Italians came home with examples of the work of Flemish artists. The greatest of such imports is probably the Hugo van der Goes altarpiece commissioned by Tommaso Portinari, the Medici agent in Bruges. But by the time this arrived in Florence around 1480, there had already been considerable contact between northern and southern artists for several decades. Rogier van der Weyden had visited Italy during the Holy Year 1450, probably passing through Florence. It is likely that on this occasion he was commissioned by the Medici to paint the *Entombment* which is now in the Uffizi. 12

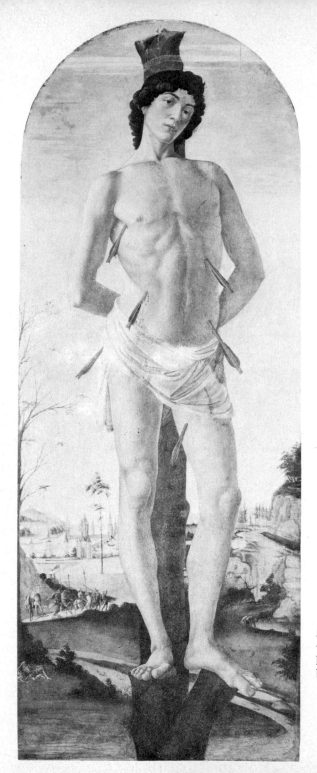

8, 9 *St Sebastian*, with detail of landscape background

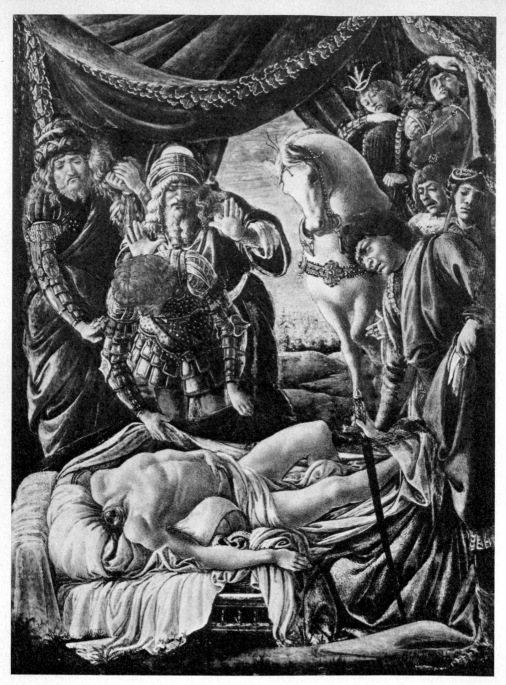

10 *The Finding of the Body of Holofernes*

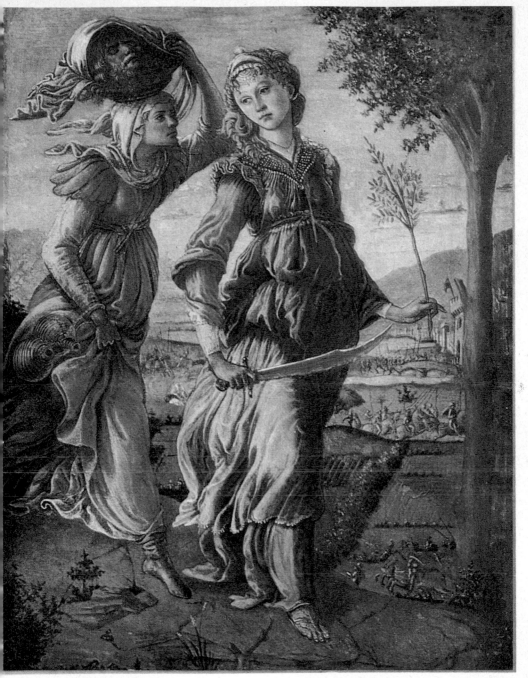

11 *Judith and her Maid*

Although he used an Italian model for the composition and iconography, Rogier has translated the whole into a Flemish idiom. The emotional scene in the foreground contrasts sharply with the finely rendered background and the tiny details, so much admired by the Italians. All the little figures on the road that meanders into the background are, just as in the *St Sebastian*, completely involved with their own affairs. That Botticelli knew northern painting and tried to emulate it is made even clearer in the fresco of *St Augustine in his Study* painted in 1480. This picture, together with a *St Jerome* by Ghirlandaio was commissioned for the church of Ognissanti by the Vespucci family.

15

12 ROGIER VAN DER WEYDEN *Entombment*

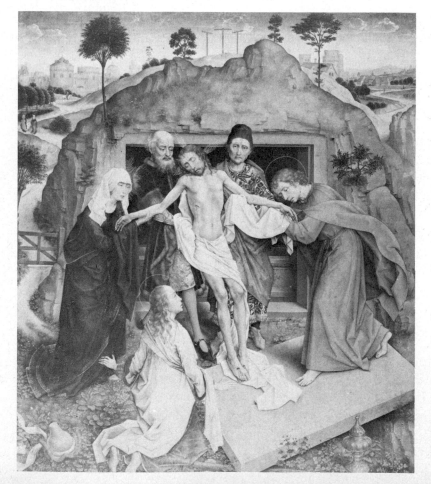

While not the wealthiest of Florentine families, the Vespucci had attached themselves to the Medici early in the fifteenth century and, as a result, had held high offices in the city government regularly after 1434 when Cosimo il Vecchio returned from exile. (The one member of the family to gain enduring fame did not follow the family fortunes in Florence but instead became an explorer and eventually gave his name, Amerigo, to the New World.) Ognissanti was not only under the patronage of the Vespucci, but was also the parish church of the Filipepi family.

Vasari describes the fresco: 'In Ognissanti he [Botticelli] painted for the Vespucci a fresco of St Augustine on the impost of the door to the choir with which he tried to surpass all those who were painting at the time, but particularly Domenico Ghirlandaio who was painting a St Jerome on the other side. This work is spellbinding and most praiseworthy, for he has shown in the head of that saint what profound thought and acute insight can be seen in sensitive and thoughtful people who are continuously seeking the highest and most complex things.' Botticelli has painted St Augustine ensconced in his cosy cell, surrounded by the paraphernalia of learning: books, an astrolabe, an armillary sphere. The philosopher saint has stopped writing and, putting his hand to his heart, looks up with great emotion. His face, furrowed and expressive, is suffused with religious intensity. Luminous colours and forceful modelling give him a powerful presence. Ghirlandaio's *St Jerome*, on the other hand, is a far less imposing figure, for 13 although the painting corresponds in composition, Jerome's attitude and mood are that of a contemplative scholar rather than of a saint inspired by heaven.

Both the composition and the detailed rendering of the furnishings in the saints' studies are derived from Flemish models. We know that the Medici owned a *St Jerome in his Study* by Jan van Eyck, a small painting much admired at the time, as we learn from a fifteenth-century Italian reference to it: 'Jerome, like a living man, is seen in a library, done with rare art.

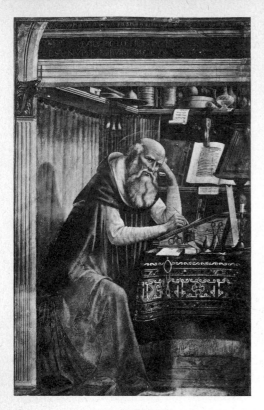

13 DOMENICO GHIRLANDAIO
St Jerome

14 JAN VAN EYCK and PETRUS CHRISTUS
St Jerome

For if you move back from the painting a little, it seems that the room recedes and that there are in it complete books laid open, while if you go nearer, it becomes obvious that there is only an indication.' Unfortunately this panel has disappeared, but it must have been similar to another of the same subject, *14* attributed to Jan and his pupil Petrus Christus. A look at it leaves us with no doubt that a painting of this kind must have been the source for Botticelli and Ghirlandaio. But while Ghirlandaio adheres more closely to the northern prototype with its rich assortment of small objects surrounding St Jerome, Botticelli monumentalizes the whole and reduces the miscellaneous odds and ends to the few items essential to convey the atmosphere of a scholar's study.

30

15 *St Augustine in his Study*. Ognissanti, Florence

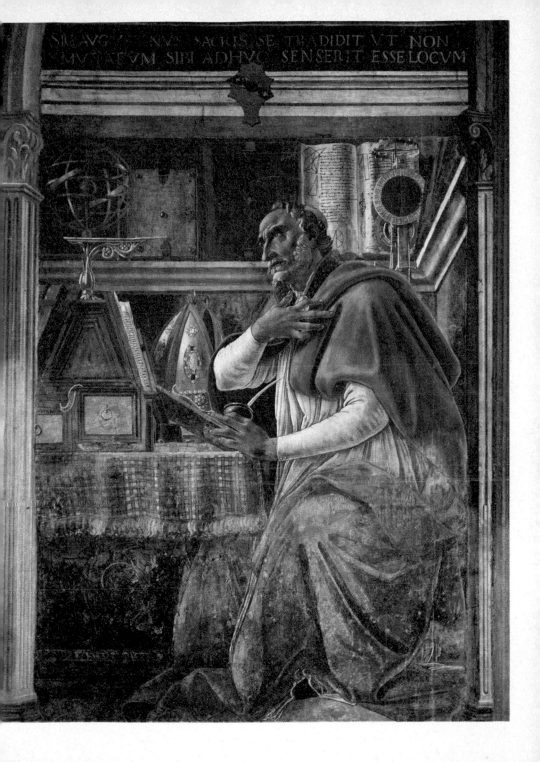

SR·AVG...NVS·SACRIS·SE·TRADIDIT·VT·NON
MVTATVM·SIBI·ADHVC·SENSERIT·ESSE·LOCVM

One of the themes which Botticelli treated again and again during the 1470s was the Adoration of the Magi. The story was well liked among Florentine patrons and painters, not just for religious reasons, but because it gave a chance to indulge in much display of riches and finery. Perhaps the most characteristic example is the altarpiece painted for the Strozzi family by Gentile da Fabriano in 1423, which is so laden with gold that even the feet of the dove hovering over the head of the third king are two little golden blobs. Here, as elsewhere, the train of the Magi fills the whole picture as it winds its way through the hills, twisting and turning in the sinuous lines so beloved of the International Gothic style — the decorative, essentially medieval style popular all over Europe in the first half of the fifteenth century, and which retained its popularity in Florence until well after 1450. The family chapel of the

16 FRA ANGELICO and FRA FILIPPO LIPPI
Adoration of the Magi

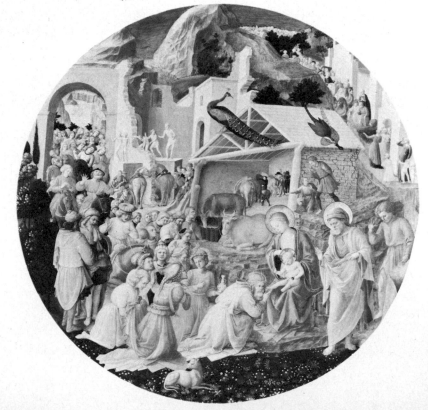

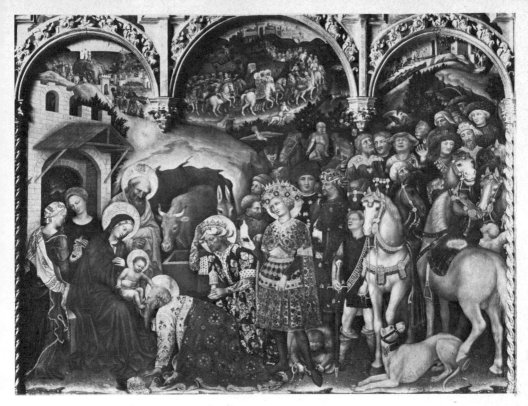

17 GENTILE DA FABRIANO *Adoration of the Magi*

Medici Palace was decorated with the Journey of the Magi about 1460 by Benozzo Gozzoli who covered the walls with an elaborate landscape and an exuberant, colourful crowd surging towards the Holy Child. The Medici in any case seem to have had a special affection for the Magi and we know that Cosimo il Vecchio had a painting of their story in the private cell which he reserved for himself in the convent of San Marco.

One example that Botticelli surely knew and from which he did in fact borrow some figures is a tondo attributed to Fra *16* Angelico and Filippo Lippi. Although there is not as much gold as on Gentile's picture, the intricate intertwining of horses, men and landscape follows in the tradition of International Gothic.

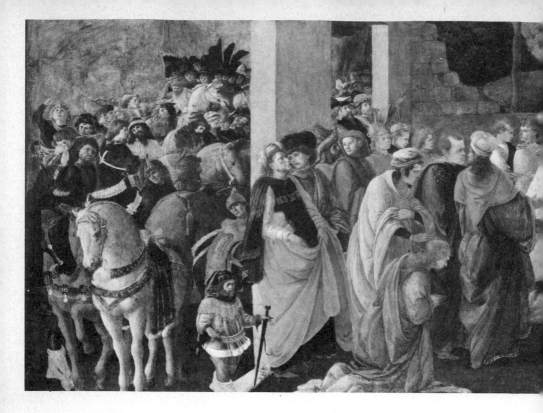

The pattern of this procession has been carefully designed to harmonize with the circular shape of the tondo, a shape which was popular in Quattrocento Florence because of the challenge the form offered to the ingenuity of artists.

Botticelli's four surviving versions of the *Adoration of the Magi* show a definite development in both composition and style. Since none of the commissions survive no firm dates or patrons can be assigned, .but the order in which they were

18 painted can still be established. The earliest, a long, low panel is, as may be expected, a conventional and still tentative exercise. The picture is divided into three parts, progressing from left to

19 right. To the extreme left is the train – horses, courtiers, even a dwarf – in the centre are the Magi with attendants, and to the

34

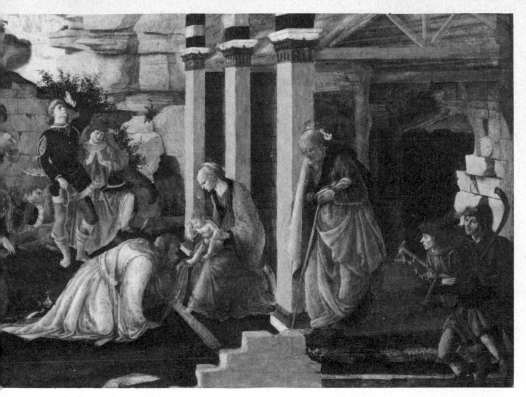

18 *Adoration of the Magi*

right is the Holy Family. Although the restricted height of the panel hampered Botticelli's freedom, he has attempted to suggest the twisting lines of a procession by splitting the retinue into two groups flowing around rocks and ruins. The three Magi are separated from the train by the remains of a wall. One still stands, the second is removing his crown, and the third is already kneeling in adoration of the Child, as is the standard arrangement. Against the white and grey pillars the Virgin and Child sit isolated, St Joseph and the shepherds being placed to the extreme right. The Virgin's delicate profile and the simplicity of the surroundings set her apart from the confusion of the masses, giving her the quiet dignity befitting the Mother of God.

20

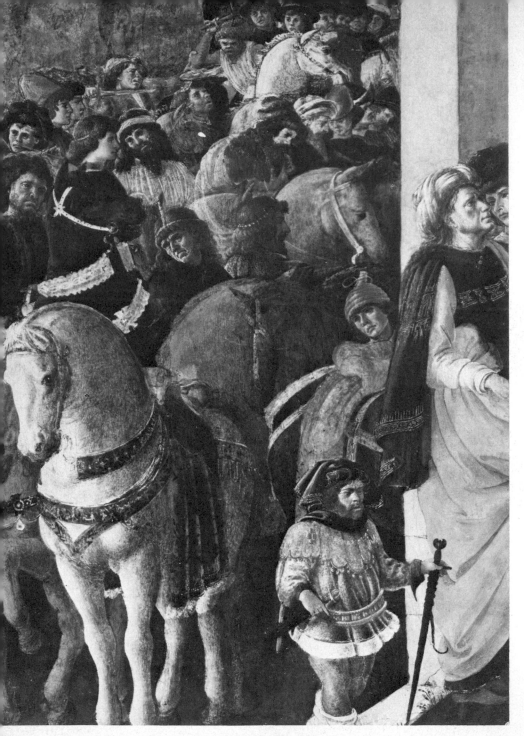

19, 20 *Adoration of the Magi* (details of pl. 18)

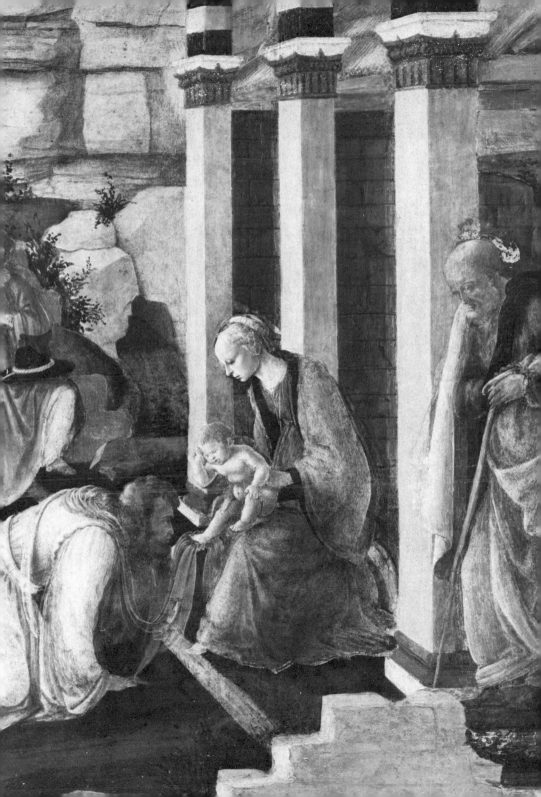

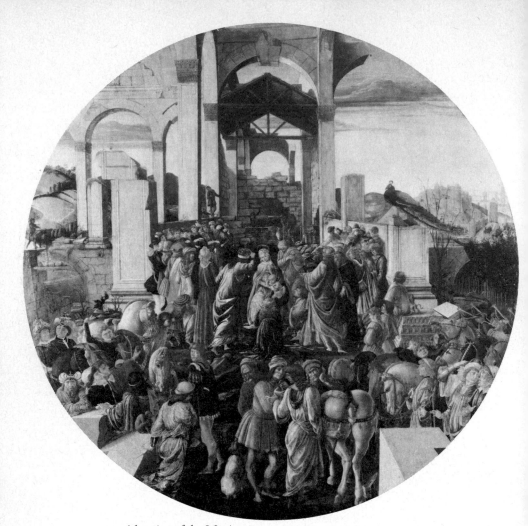

21 *Adoration of the Magi*

When Botticelli treated this subject again he used the tondo
21 form on a panel identified with a picture mentioned in Vasari's
second edition (1568) as then being in the house of the Pucci
family. This work, although the figures are close in style to the
22 earlier version, has two remarkable innovations: the Virgin has
been placed in the centre of the composition, fully frontal, and
she is elevated on steps surrounded by monumental pseudo-

classical architecture. While there are a few earlier examples of a centralized composition for the Adoration of the Magi, the Virgin had not been raised above the crowd as is done here. Furthermore she is in the exact centre of the tondo, and in consequence it is she, rather than the Magi, who becomes the focus of attention. Her significance is also emphasized by the remains of ancient architecture flanking her and the small wooden roof over her head, inserted between marble pillars to

22 Virgin and Child (detail of pl. 21)

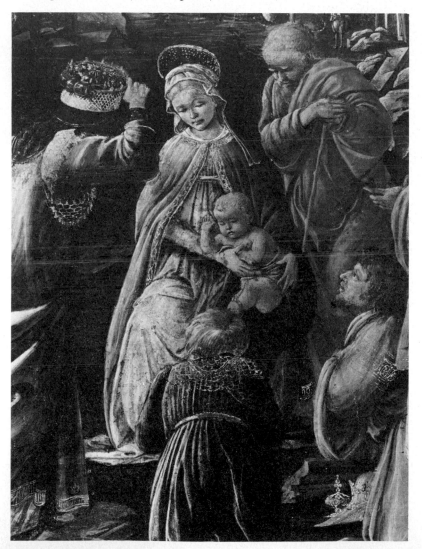

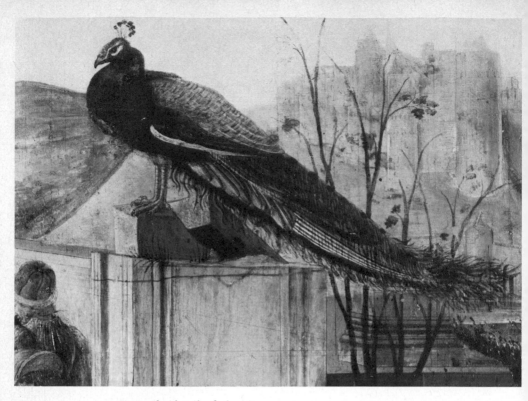

23 Peacock (detail of pl. 21)

suggest the stable. Signs that Botticelli carefully constructed this elaborate space can be easily seen from the pentimento visible beneath the peacock to the right. The use of classical structures in scenes relating to the Nativity was common in late fifteenth-century painting, since it was meant to refer to the destruction of the ancient pagan world with the coming of Christ. But never before had this picturesque symbol assumed such prominence in an *Adoration of the Magi*.

The device of elevating Virgin and Child is developed still further in the next *Adoration* painted by Botticelli, one of his finest works. Originally placed on an altar to the right of the main door of S. Maria Novella, the picture was still in its original place when Vasari saw it and claimed that members of the Medici family had been portrayed as the three Magi. This

23

26

has led to much discussion and speculation and the issue has been confused by the publication of documents that had been incompletely researched and inaccurately transcribed. Just why members of the Medici family were commemorated as Magi cannot be answered, but their presence seems beyond doubt. Unlike the heads of the Magi in Botticelli's other *Adorations*, these are all clean-shaven and clearly articulated. They are not 'types', but individuals. The eldest, as a comparison with a well- *103* known medal shows, bears unmistakably the profile of the *24* founder of the dynasty, Cosimo il Vecchio, who had died in 1464. The second king, kneeling immediately beneath the *104* Virgin, can be identified as Piero il Gottoso whose death had occurred in 1469. A comparison of his features with the bust of Piero by Mino da Fiesole makes this a certainty. The third of the *25* Magi, in a white dress and kneeling a little more to the right, is difficult to identify, but he might be Lorenzo il Magnifico's younger brother Giuliano (murdered in 1478), as already suggested by Vasari in his first edition (1550). A comparison with the famous medal, struck to commemorate the failure of the Pazzi conspiracy, shows a striking similarity. If these identifications are correct, the three Magi would portray members of the Medici family who were dead when this picture was painted some time during the late 1470s. This is not surprising. Although portraits of living contemporaries were common enough as onlookers to religious scenes, the Florentines of the fifteenth century were too devout to assume the masks of saints. More important, these three identifications would fit the standard iconography of the three Kings who traditionally represented the three ages of man: youth (Giuliano), middle age (Piero) and old age (Cosimo il Vecchio). Vasari also suggests that the man in the yellow cloak on the extreme right looking out of the picture is a self-portrait of *105* Botticelli, but since no other certain portraits exist, this claim cannot be substantiated. In any case, it is unlikely that a fifteenth-century painter should have included his own full-length likeness in so prominent a place.

41

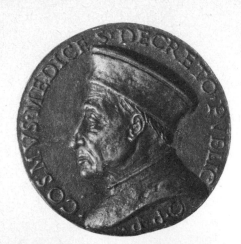

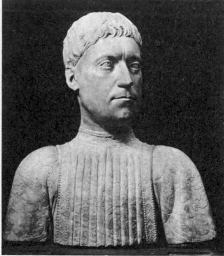

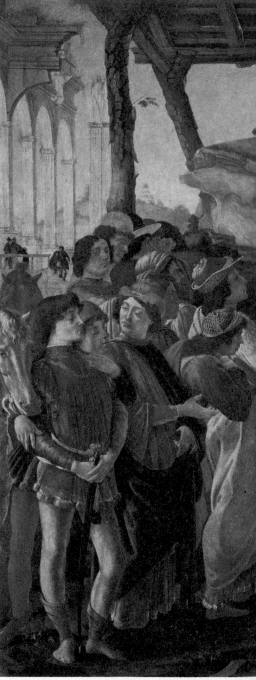

24 Medal of Cosimo il
Vecchio

25 MINO DA FIESOLE Bust of
Piero de' Medici

26 *Adoration of the Magi*

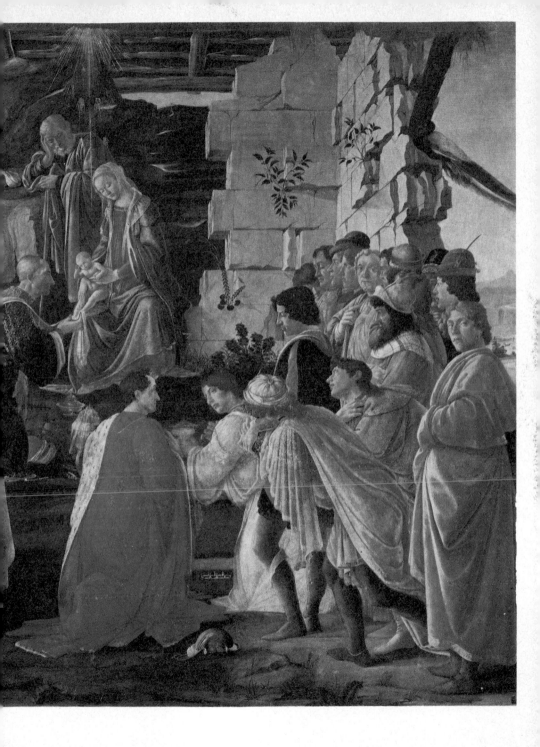

28 The next *Adoration* is sometimes identified with a painting done in Rome that is mentioned by early sources, but this cannot be proved. The Virgin and Child are placed in the middle ground again sitting under a ruined classical structure with a simple wooden roof inserted. But instead of physically elevating the Virgin Botticelli uses a different device. He has arranged the train of the Magi into two crescents around the Virgin, leaving the ground directly in front of her empty. All are leaning towards her in postures of ardent devotion and the few who are unconcerned are carefully removed to the back rather than being integrated with the rest. The entire emphasis on an intense moment with strong individual gestures and careful placing of each figure makes for a 'staged' appearance. This is not meant to be a pejorative judgment but rather to indicate yet another new element in Botticelli's art. This formality of structure increases in his work through the 1480s and finally hardens in his last works.

Perhaps the most important question raised by the renderings of the Adoration is Botticelli's relationship to Leonardo da Vinci, whose famous painting of the same subject was still unfinished when he left Florence for Milan in 1482. Leonardo is often credited with the introduction of symmetry in his *27* *Adoration*, thereby making it one of the earliest examples of

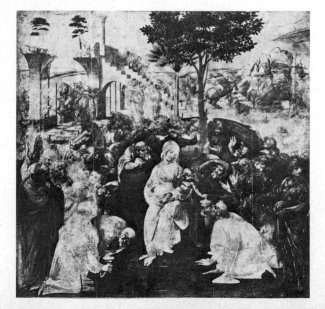

27 LEONARDO DA VINCI *Adoration of the Magi*

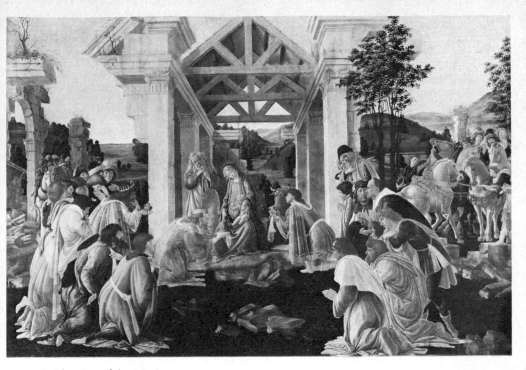

28 *Adoration of the Magi*

High Renaissance style. Yet this element is already present in Botticelli's *Adorations*, excepting of course the early oblong one. In the London tondo and in the Washington panel Botticelli has not only employed a monumental piece of architecture made up of classical elements in the centre of his composition, but has carefully placed the Virgin in the centre. In the Uffizi *Adoration* 26 the architecture, although not pseudo-classical, is of equal importance because it elevates the Virgin, placing her at the apex of a pyramid formed by the kneeling Magi. Since this picture must have been completed before Botticelli went to Rome and was prominently displayed in S. Maria Novella, it would certainly have been known to Leonardo, who further developed the compositional formula of a centralized Virgin by making her much larger in relation to the other figures, and by placing her farther forward, thereby eschewing the reliance on architecture to stress the focal point.

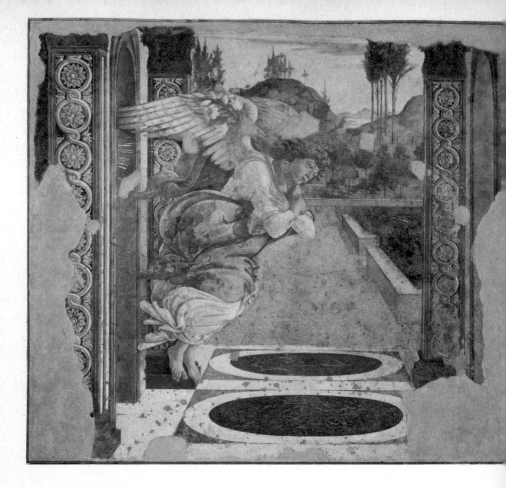

The last major religious work done by Botticelli before his
29 departure for Rome was a fresco of the *Annunciation* executed in
the spring of 1481 for the porch of the church of the Hospital of
San Martino della Scala. An immensely impressive work, it
suffered much damage through the centuries and has only
recently been beautifully restored to some semblance of its
former grandeur. Gabriel, still airborne, flies in from the left, his
cloak swirling around him, his lily bent from the force of the
wind. Behind him stretches a garden and beyond a distant
landscape. The Virgin on the right, separated from the angel by

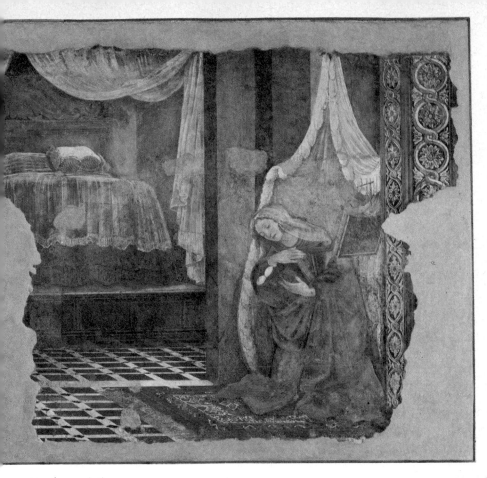

29 *Annunciation*

a wall with a round-headed entrance, is kneeling inside her bedroom, her graceful and slender figure bending as if in fear and submission. Once again the influence of the north can be seen, both in the landscape behind Gabriel and the domestic details of the Virgin's room. The magnificent motion of the angel and expressive gesture of the Virgin make this one of Botticelli's finest paintings. In its depth of feeling it is far superior to the rather mannered and affected depiction of the same subject which he was to paint seven or eight years later.

47

Late in 1481 Pope Sixtus IV invited Botticelli and three other painters to come to Rome to decorate the walls of the newly built chapel in the Vatican Palace, the Sistine Chapel. Botticelli's colleagues were two Florentines – Ghirlandaio and Rosselli – and an Umbrian (who had worked for the Pope before), Perugino. Surviving documents do not bear out Vasari's claim that Botticelli was entrusted with the supervision of the whole ambitious scheme. As so often the Tuscan historian was too anxious to show that everything remarkable had been done by his fellow countrymen. In truth it is most likely that Perugino was in charge, as he painted the altarpiece (which later had to make room for Michelangelo's *Last Judgment*) and the two frescoes flanking it on the same wall, thereby setting the key for the rest of the decorations.

The Sistine Chapel was not built for daily private devotions of the pope – there were more suitable smaller rooms in the palace serving this purpose – but it was destined to be used by pope, by the Curia (the papal administrative body) and distinguished visitors on high festivals and ceremonial occasions, and above all was to be the meeting-place of the Conclave, the assembly of cardinals from all over the Catholic world which met every time a new Pontiff had to be elected. The decorations were carefully planned with these functions in mind, and artists of distinction were chosen to create a worthy setting.

The chapel is unusually large, being 40m long, 13m wide, and almost 21m high. The walls have been divided horizontally into three bands, separated from each other by broad cornices. The lowest is painted with simulated curtains decorated with Sixtus IV's family emblem, the della Rovere oak. The most significant and conspicuous zone is the middle one with its elaborate narrative frescoes depicting the lives of Moses and Christ. Originally they began on the altar wall, showing to the spectator's left the Old Testament stories and to the right those of the New Testament. But Michelangelo had to destroy the frescoes of the *Finding of Moses* and the *Nativity*, while the two concluding incidents on the opposite entrance wall suffered

damage and were repainted in the sixteenth century in so brutal a fashion that they may be disregarded. We are therefore left with six frescoes on each of the side walls, still giving magnificent proof of the Pope's intentions and of the skill of his painters.

The frescoes are separated from each other by painted pilasters, and each of the twelve paintings – resplendent in bright colours after the recent cleaning – contains not just one incident, but several – Botticelli's *Youth of Moses*, for example, *30* depicts no less than seven scenes. A Latin inscription on the cornice above indicates the general topic of each fresco.

In the uppermost zone, the clerestory, the painted full-length images of the early popes appear between the windows. These, according to a surviving contract, must come from the workshops of those painters who executed the narrative frescoes immediately below them. This means that each artist and his assistants were given an entire bay for decoration and after completion of this task the team moved on to another bay. The contract mentions only the four artists listed above, but Vasari says that Signorelli painted the last fresco on the Moses wall, and his statement is proved correct on stylistic evidence.

Seen as a whole the fifteenth-century paintings of the Sistine Chapel celebrate the founders of the Old and New Covenants in their roles as lawgiver, ruler and priest, and the addition of the papal portraits carries the argument forward into the times of the Church.

Obviously the artists whom Pope Sixtus had commissioned cannot have been left to their own devices, as it would hardly have been enough to ask them to paint scenes from the two Testaments. Even if taken by themselves, these Quattrocento decorations present us with a lengthy and intricate series of incidents, planned in such a manner that each carries a certain meaning, whatever its pictorial appeal. We must therefore assume that some programme was worked out beforehand, and that the painters were advised by one or several theologians. Sixtus himself could have played an important role in deciding the topics since he was a Franciscan scholar of renown.

49

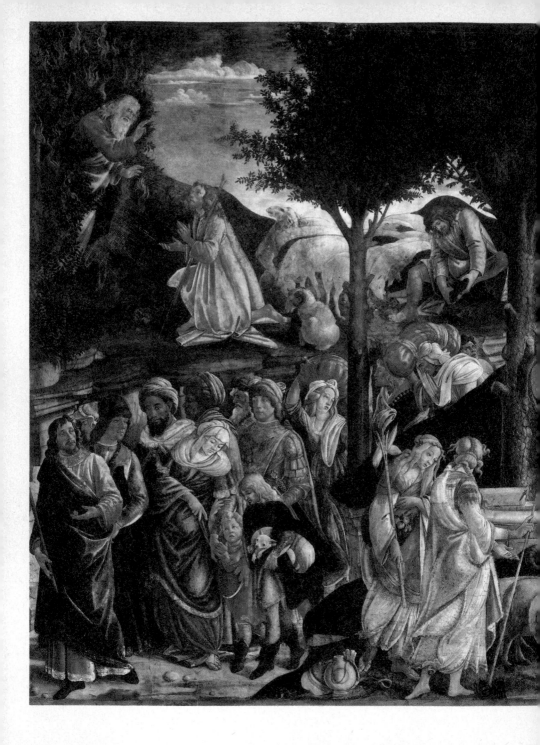

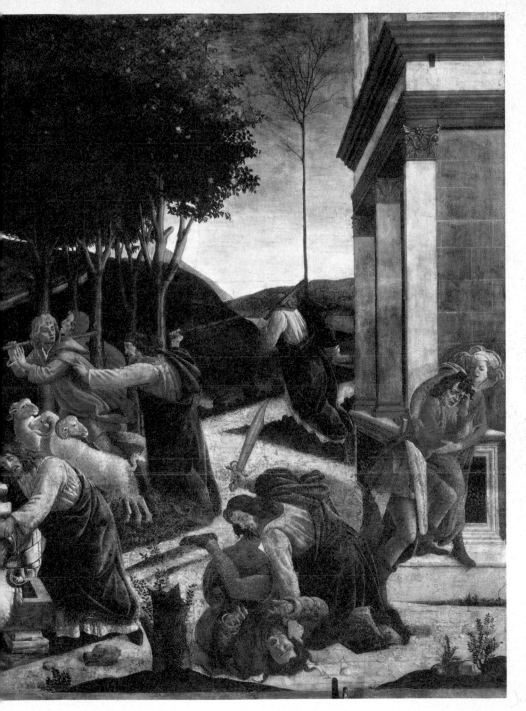

30 *The Youth of Moses*. Sistine Chapel, Rome

There must also have been a strong-minded and generally respected personality supervising the execution of the decorations, since the homogeneity of appearance is remarkable, considering that they were produced by five different artists and their assistants. At a first glance, scale, composition, relationship of foreground to background, and notably the handling of colour vary but little from fresco to fresco, and only a closer analysis reveals the traits of personal style. Perugino proved an excellent choice for the role of artistic director.

A modern beholder might complain that such strict control over form and content must have constrained artistic freedom. But a painter of the fifteenth century did not subscribe to that romantic fallacy which holds that only one who is a law unto himself can be a true artist. Botticelli and his contemporaries worked in accordance with given standards. They gave their best by meeting the challenge of a commission which laid down both formal and iconographic patterns, and their patrons most admired the skill which artists employed in extending pictorial traditions without destroying them.

This is the context in which we must see Botticelli's contribution in the Sistine Chapel, and for that reason it had to be described at some length. In Rome he was a member of a team and he had to work within a closely defined programme. Yet he could still show his genius by the way in which he gave life to the dry bones of the texts he had to illustrate.

We do not know on what basis the artists in the Sistina were allotted their bays, but we do know from Vasari that Botticelli executed three frescoes (and, of course, the papal portraits above them), two in the Moses cycle, and one in the Christ cycle.

Quite apart from having to combine several biblical scenes within one frame, the painters working on the Moses series to the left of the altar encountered an additional difficulty. The story begins, as is customary in such narrative cycles, at the altar, and this means that strictly speaking the action should run from right to left, while we normally read pictures, like script, from left to right. In the first fresco Perugino oddly enough ignored

this demand. In the left half of the picture the angel of the Lord stops Moses and his family, in the right half Zipporah circumcises her son in accordance with God's demand implied by the angel's action. But on the second fresco Botticelli has employed great ingenuity in unfolding his tale from right to left.

Seven scenes from the early life of Moses had to be accommodated in this painting. It begins on the right with the slaying of the Egyptian taskmaster and, following upon it, Moses' flight. In Midian he encounters Jethro's daughters, drives away the shepherds who had molested them, and gives water to their sheep. Next he hears the voice from the Burning Bush, and obedient to its command, takes off his sandals and kneels down to receive his mission. Finally he is seen at the head of his family returning to Egypt to liberate the Israelites.

30

While these events are arranged in chronological order, Botticelli, with his characteristic sense of drama, has created a composition in which Moses is the dominating figure of each episode, and his gestures – made even more striking by the brilliant yellow and gold of his dress – take us from one scene to the next. At the same time a triptych-like division, a compositional formula often employed by Botticelli, gives structure to the narrative, with the trees separating the three parts. The murder of the Egyptian taskmaster and Moses' flight appear in the right 'wing', the meeting with daughters of Jethro fills the centre, and the encounter with God the left section.

Botticelli, the storyteller, shows his mastery in many ways. The right part of the fresco is filled with violent actions: the murder, the flight, and the driving away of the shepherds. These are in strong contrast with the idyll shown in the centre: Moses giving water to the sheep of Jethro's daughters. Yet this charming scene was hardly given such prominence only because it delights the eye; theologians argued that this little incident prefigures Christ's care for His Church, and that is why it was given so conspicuous a place here. Yet even those not versed in the complexities of biblical exegesis can grasp the compassion with which Moses ministers to the needy.

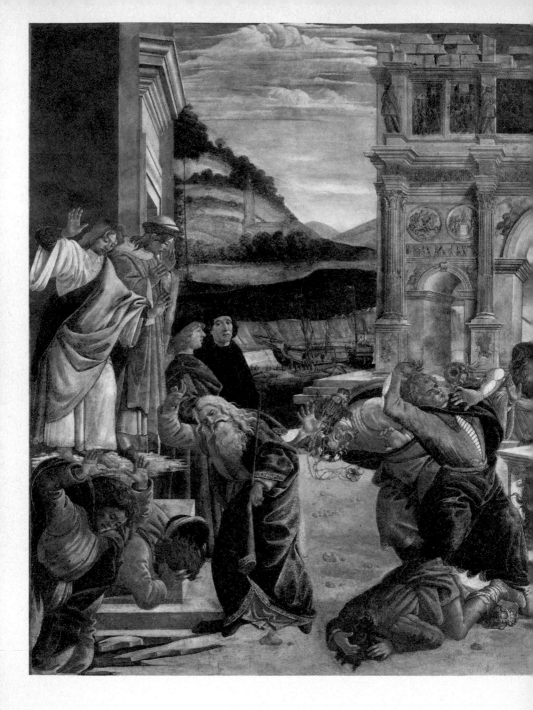

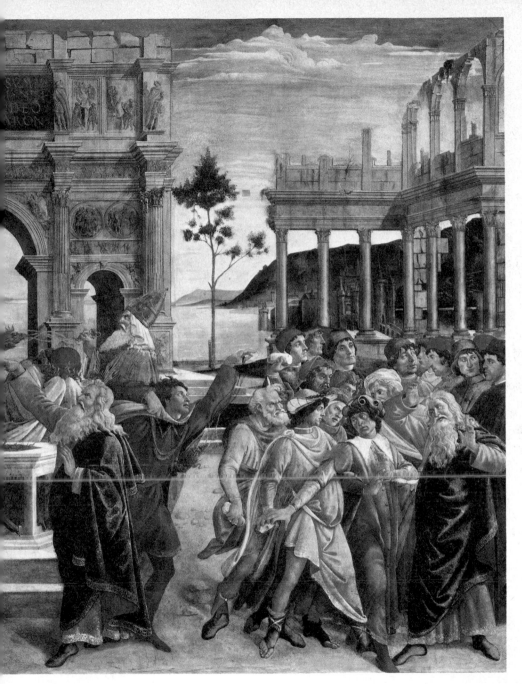

31 *The Punishment of Corah*. Sistine Chapel, Rome

32 The daughters of Jethro (detail of pl. 30)

It might be noted in passing that Zipporah, the more prominent of the girls and Moses' future wife, inspired Marcel Proust's description of Odette.

The first meeting between Moses and the Lord is, of course, of central importance in the whole cycle, for it was this event which made Moses the leader of his people. To drive home this point Botticelli has used a telling pictorial device. The two figures appear on elevated ground above the others and they are disproportionally large considering their placement in the fresco. But perhaps the most remarkable touch is the splitting of the scene into two episodes, not a unique but an unusual arrangement. First Moses must remove his sandals, obedient to God's command: 'And he said, Draw not nigh hither: put off thy shoes from off thy feet, for the place whereon thou standest is holy ground' (Exodus iii,5). Then to the left in proper narrative sequence Moses is seen kneeling before the Burning

Bush listening to God's words. The significance of the event could not be demonstrated more fully.

The final scene in this fresco gives us yet another example of Botticelli's subtlety. Moses at the head of his family moves to the left, and his gesture clearly directs us to the next fresco, the *Crossing of the Red Sea*, painted by Cosimo Rosselli. The continuity of the story from one painting to the next is thus made explicit. But unfortunately Rosselli was a lesser master and his work lacks the finesse and sophistication of Botticelli's.

His other fresco in the Moses cycle gives even stronger proof *31* of his understanding, and it is obvious that the earlier experience was put to good use. This time he had to represent three acts of disobedience by the Israelites, but unlike in the *Youth of Moses* their chronological sequence was of no importance. Again the tripartite organization of the fresco is apparent. The central episode commands our immediate attention, not just by virtue of its position, but because it is dominated by a triumphal arch which is exactly copied from the Arch of Constantine. Beneath it Aaron stands by the altar, swinging a censer and near him, Moses, his rod lifted high, calls from heaven the punishment on those who have usurped his brother's priestly function (Numbers xvi, 28–30). To the right Joshua attempts to hold back a crowd of rioting Israelites trying to stone Moses (Numbers xiv, 6–10), and to the left the earth has opened at Moses' command to swallow up Corah and his followers who had risen against him. By a miracle only those innocent of the conspiracy are saved by being lifted up above the chasm (Numbers xvi, 32).

The rhythmic composition of the fresco clearly separates the three events without in the least breaking up the unity of the whole, and if it were not for the fact that Moses appears three times, we might easily think that we were witnesses of one single story of violence and rioting. Botticelli's high sense of action is most apparent in this fresco, and so is his ability to render gestures and expression in a compelling way. Of the men who worked in the Sistine Chapel, their abilities notwithstanding, he emerges as the best theatrical producer.

For the Christ cycle Botticelli painted only one fresco – the second along the wall, coming after Perugino's *Baptism* and before Ghirlandaio's *Calling of the First Apostles* – but he was given a particularly taxing assignment. He had to depict the Temptation of Christ, but at the same time he had to show, for 34 theological reasons, an Old Testament blood sacrifice, probably illustrating a passage from the Epistle to the Hebrews (Ch. ix). (The explanation given in most guidebooks that the scene represents the Cleansing of the Leper is not correct.) The inclusion of such a scene within an imagery which is not only narrative but also didactic makes perfect sense. Literal sacrifices, as enacted before our eyes on this fresco, belong to the Age of Law, but Christ's self-sacrifice and the symbolic sacrifice of the Eucharist, as depicted by Rosselli on the last fresco of the same wall, mark the Age of Grace. It is precisely this difference between the nature of Jewish and Christian sacrifice which the Epistle to the Hebrews discusses at length.

The two topics which had to be combined seem to have nothing in common, and Botticelli's solution could only have been found by a painter gifted with an unusual degree of intelligence and imagination. The Temple at Jerusalem is the one element which fortuitously occurs in both, and Botticelli has made it the pivot of his composition. People rush in from all 33 sides to attend the sacrificial rite which takes place by the altar in front of it. The High Priest and his attendant with the dish of 35 blood loom large in the middle. But directly above them on the pinnacle of the Temple appear Christ and Satan, in accordance with the Gospel account of the second of the three temptations: 'Then the devil taketh him up into the holy city, and setteth him on a pinnacle of the temple, And saith unto him: If thou be the Son of God, cast thyself down; for it is written, He will give his angels charge concerning thee; and upon their hands they shall bear thee up . . .' (Matthew iv, 5–6). Yet this twofold function of the Temple is more than a clever pictorial device. Through it we are reminded that Christ came to fulfil the Law and that the Temptation occurred before He began His ministry. The ease

59

33 Woman carrying chickens (detail of pl. 34)

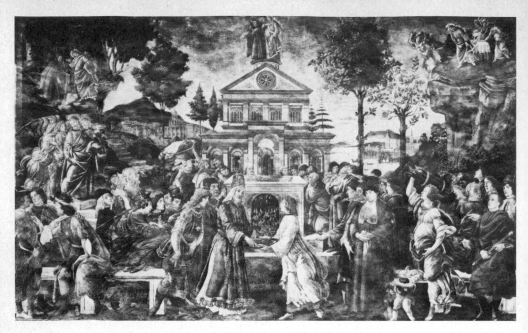

34 *The Temptation of Christ.* Sistine Chapel, Rome

with which Botticelli has visualized complicated concepts is something we shall meet again in other of his works.

The sacrifice with its many figures spreads right across the foreground of the fresco. Behind and above it to the left appears the first of Christ's three temptations with the devil asking Him
36 to change stones into bread; to the right is the last, the devil having taken Christ to a high mountain offering Him dominion over the world. For this episode Botticelli has chosen the most dramatic moment, Christ's rejection of the devil: 'Get thee hence, Satan' (Matthew iv,10). But he has added a charmingly imaginative yet surely symbolic touch by also illustrating what followed upon Christ's victory over His adversary: 'and, behold, angels came and ministered unto him' (Matthew iv,11). The Bible does not specify the nature of these ministrations, but Botticelli took them quite literally and painted three angels setting a table, complete with tablecloth, and placing on it the symbols of the Eucharist, bread and wine.

60

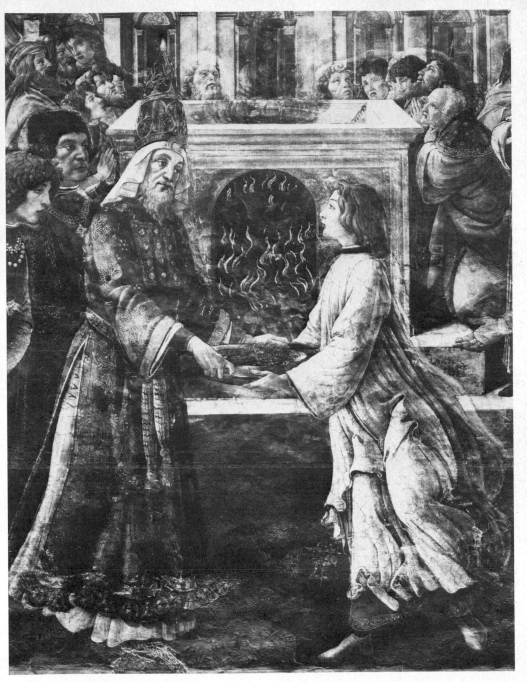

35 Priest and deacon preparing the sacrifice (detail of pl. 34)

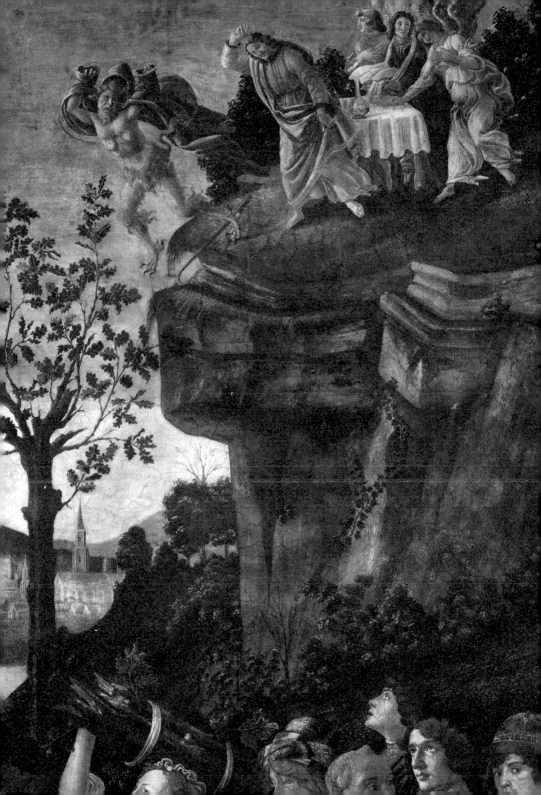

The figures of the Temptation scenes are smaller than those of the sacrifice, but Botticelli has compensated for this by the device of dividing the fresco into two horizontal zones, placing all appearances of Christ into the upper one. It is therefore quite easy for the beholder to distinguish the New Testament narrative from the Old Testament sacrifice, but the pictorial unity of the fresco is not disturbed.

One other feature still has to be mentioned because it is particularly obvious in this fresco. If we look at the figures Botticelli painted for the sacrifice scene, it strikes us that they are *37* clearly of two different kinds. The active participants are clad in those ample cloaks which were traditional for biblical personages, and the High Priest's robes are in fact accurately reconstructed from biblical accounts. But there are also many onlookers in contemporary Quattrocento dress. Several of them have highly individual features and it is almost certain that they are portraits. This is a practice often found in the late fifteenth century, and in the Sistine Chapel members of the Pope's circle are most likely to have been honoured in this way. Not surprisingly, this situation has given rise to a large number of guesses and suggestions, some of which are discussed in a later chapter. We would love to know their identity, but for lack of real evidence none of the many identifications proposed can be proved.

The sojourn in Rome saw Botticelli's style reach maturity. By the time of his return to Florence in 1482, the deep sensitivity that was already apparent in his *St Augustine* and San Martino *Annunciation* had broadened into an ability to grasp deep intellectual issues and to translate them into compelling images. Botticelli's religious paintings of the 1480s are deceptively simple in their formal arrangement while subtly including a complex iconography. Although none of his commissions were ever again to include such intricate problems as he faced in the Sistine Chapel, the paintings of the next decade have a strength of expression and a depth not found in his pre-Rome works.

37 Bystanders and woman bringing sticks (detail of pl. 34)

The city of Florence could not match the grandeur of the Sistina commission. The few public works for which Botticelli received commissions were never carried through, and work done for private patrons was of necessity on a smaller scale. But the number of these private commissions quickly made up for the lack of large-scale public projects and both he and his assistants must have had plentiful work for the next ten years.

Among his most important works are the four surviving altarpieces produced during this period. What appears to be the earliest of these was ordered as the high altar for the Augustinian church of S. Barnaba, a fourteenth-century structure built to commemorate the Battle of Campaldino in 1289, which had been fought on the feast day of the saint. The battle had a special place in Florentine lore, for the city had gloriously defeated the army of Arezzo.

38 The basic form of the altarpiece is fairly straightforward. The Virgin and Child enthroned with six saints are grouped as if talking together informally – the so-called *sacra conversazione*, a conventional arrangement for altarpieces in the Quattrocento. But the green marble base on which the Virgin's throne is elevated has an unusual text for a high altar, the opening prayer of the Canto XXXIII of Dante's *Paradiso*: 'Vergine madre, figlia del tuo figlio' (Virgin mother, daughter of your son). Dante had fought at the Battle of Campaldino on the side of Florence, a fact of which the Florentines were inordinately proud. The inclusion of this passage, one of the most famous in the *Divine Comedy*, on this altarpiece is no doubt in his honour. The Florentines felt a nagging sense of guilt for having treated their most celebrated poet so badly during his lifetime.

More conventional Christian iconography can be found above the throne where two tondi in grisaille depict the
40 Annunciation and two angels flanking the Virgin hold the crown of thorns and the nails of the Passion. Two other angels pin back the curtains revealing the Madonna and Child. Christ leans forward in His Mother's arms, His hand raised in blessing.

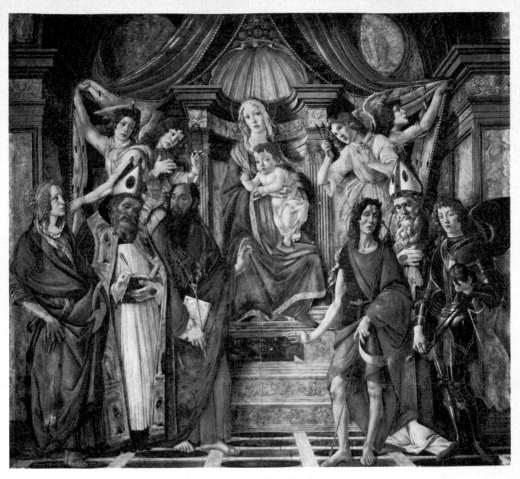

38 *Virgin and Child with Saints (S. Barnaba Altarpiece)*

Each saint attending the Virgin has been carefully chosen for his or her significance. In the place of honour to the Virgin's right stands St Barnabas, the patron saint of the church. Next to him is St Augustine, the patron of the canons of the church, who is in turn followed by St Catherine of Alexandria, the patroness of philosophy and education. On the other side of the throne are St John the Baptist, the patron saint of Florence, St Ignatius, known as the 'beloved of Christ' and one of the early writers for the Church, and the Archangel Michael, who gives

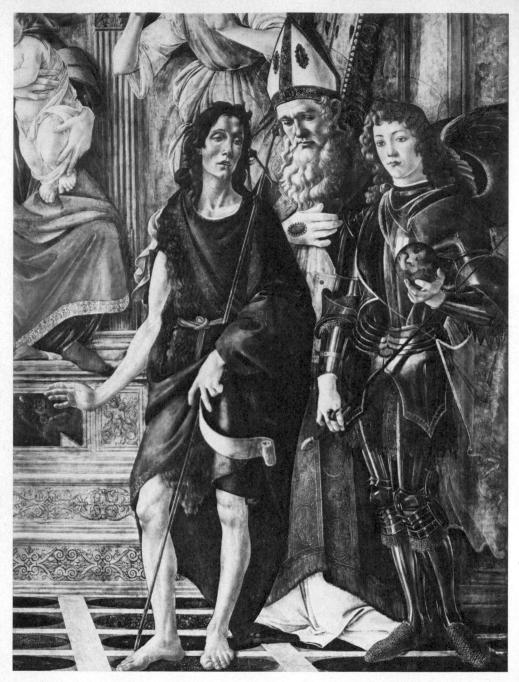

39 St John the Baptist, St Ignatius and the Archangel Michael
(detail of pl. 38)

aid in battle. The almost life-sized figures of the saints have a monumentality and dramatic presence reminiscent of the protagonists on the Sistine Chapel frescoes. Even more remarkable is their individual characterization and the subtle difference in their expressions, most striking in the contrast between the cool aloofness of St Catherine and the neurotic tension of St John, the latter much influenced by the late works of Donatello. *39* Figures such as his carved wood Magdalen in the Baptistery or the St John the Baptist on the right of one of his pulpits in the church of San Lorenzo, their bodies shaken by inner stress and their features distraught, must have greatly impressed Botticelli.

40 Angels (detail of pl. 38)

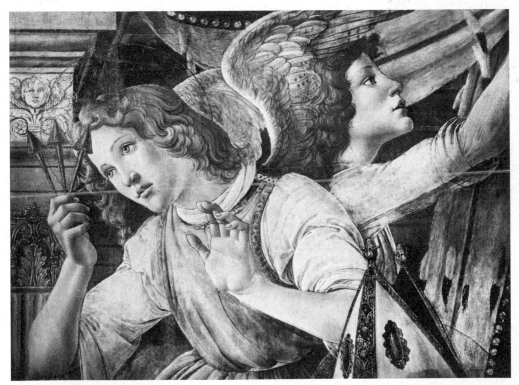

OVERLEAF:

41 *The Mystic Nativity*, 1500

42 *The Mystic Crucifixion*

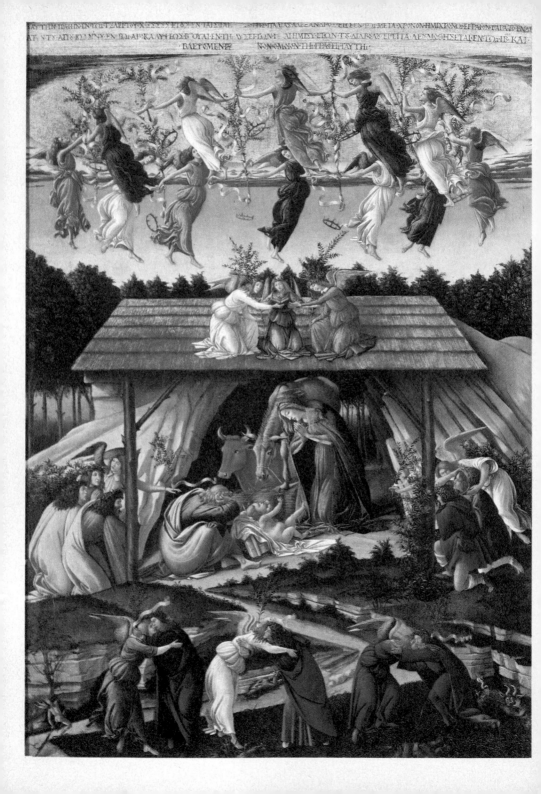

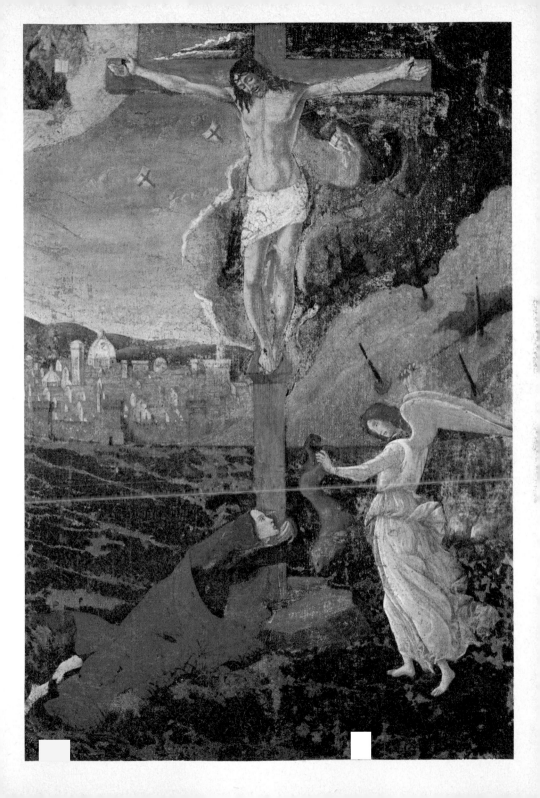

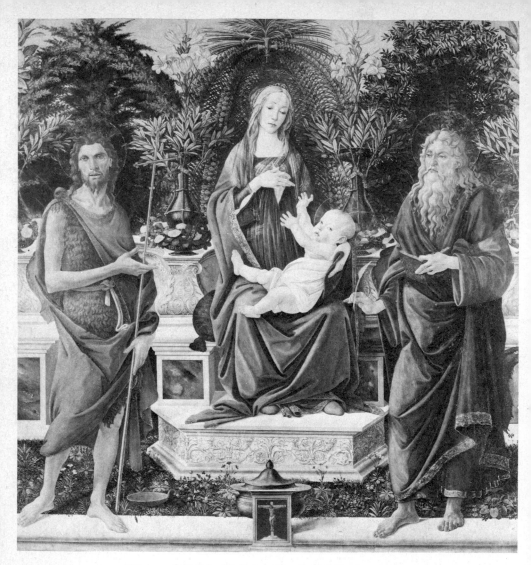

43 *Virgin and Child with Saints (Bardi Altarpiece)*

From surviving accounts we know that in August 1485, Botticelli received payment from the Bardi family for the altarpiece he had painted for their family chapel in the recently rebuilt church of Santo Spirito. The Bardi were well established

in Florence. Though their early prominence had declined after the financial collapse of 1346, they were associates of the Medici in the fifteenth century, and maintained their family palace on the south bank of the Arno in the parish of Santo Spirito. Giovanni dei Bardi, a merchant who had made his money through wool trade in England, commissioned the altarpiece with no expenses spared. Botticelli was allowed to spend 2 florins for ultramarine blue (powdered lapis lazuli, the most costly colour) and 38 florins for gold, while receiving 35 florins 'for his brush'. The frame was ordered from Giuliano da Sangallo, who later built the Sacristy for Santo Spirito.

Today only the central panel survives, showing the Virgin and Child enthroned accompanied by the two St Johns. But the *Bardi Altarpiece* differs from other depictions of a *sacra conversazione* in one important respect. The architectural setting, customary in Florence since Domenico Veneziano had painted his influential *St Lucy Altarpiece*, now in the Uffizi, in the middle 1440s, is replaced by a low wall and a lush garden with trees forming three arbours behind the Virgin and the two saints. The meticulous rendering of the foliage caused Vasari to pick it out for special comment, remarking that 'the olive branches and palm fronds are done with loving care'.

But it would be a mistake to see in this nothing more than an outstanding example of Renaissance 'naturalism'. With all its seeming simplicity the *Bardi Altarpiece* is a very complex religious allegory based on texts taken from Ecclesiasticus which appear on little ribbons half hidden in the foliage. The plants painted by Botticelli are specifically mentioned in this text, and their symbolism taken in conjunction with the quotations tells of Christ's sacrifice as the culmination of Divine Wisdom. This lesson is reinforced by the tiny painting with a Crucifixion below the Virgin's feet.

Once we recognize this symbolism, we understand the difficulties Botticelli faced when he received this commission. He must have had some theological adviser who gave him the text and told him what plants to depict, but the painter still had

43

to transform words into images. It is a mark of Botticelli's power of imagination that he could make of dry, theological exegesis a faultless display of vegetation which we, like Vasari, can admire for its beauty alone.

This duality of representational accuracy and symbolic meaning is typical of fifteenth-century painting. In the case of the *Bardi Altarpiece* we have the inscribed scrolls to help our understanding, but in most instances the beholder must distinguish between symbol and artist's fancy. This device has rather aptly been called 'hidden symbolism', and characterizes an age in which artists created pictures not only as visual delights but also as meaningful images deeply imbued with contemporary religion and thought.

Between 1488 and 1490 Botticelli was commissioned by the goldsmiths to paint for their chapel of St Eligius in the church of *44* San Marco a *Coronation of the Virgin*. As is usual with this topic the painting is divided into two zones, with God the Father crowning the Virgin above and an assembly of four saints below. St Eligius appears of course as the patron of the goldsmiths and the chapel, and St John the Evangelist as the patron of the silk-weavers, to whose guild the goldsmiths belonged. The other two, St Jerome and St Augustine, are the two of the four Church Fathers most frequently rendered.

Once more it is the heads of the saints which draw our *47* attention. The face of John the Evangelist in particular, filled with religious fervour, is an outstanding example of that increasing preoccupation with religious experience which became so prominent in Botticelli's art after Rome. St John looks up to heaven and holds up a blank book, about to follow the Divine command in Revelations, 'Write in a book' (Revelations i,11).

The angels dancing around God the Father and the Virgin are a new development, probably inspired by Fra Angelico's *45* *Coronation of the Virgin* which Botticelli would have seen in San Marco. Botticelli has taken Fra Angelico's delicate and stately figures to each side of the central group and expanded them into

74

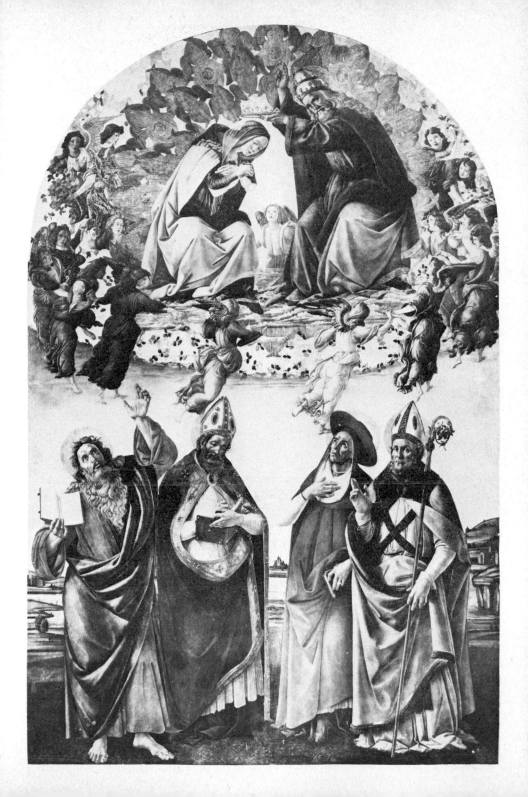

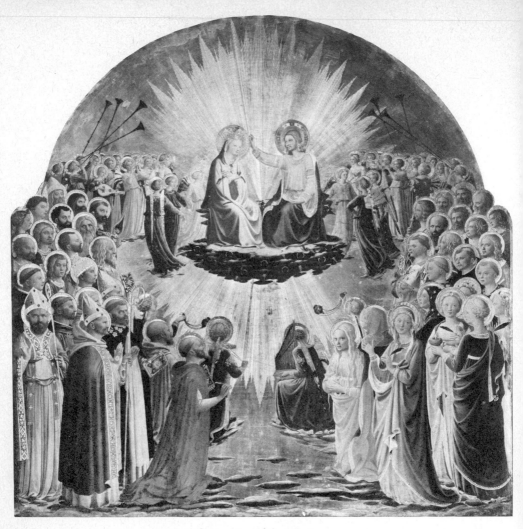

45 FRA ANGELICO *Coronation of the Virgin*

46 a full circle of vigorous movement. The feeling of space is heightened by carefully placing one angel behind the aura sent out by God, thus forcing the central group forward in the picture plane. This angel, incidentally, deeply impressed the English artist Burne-Jones when he saw it in 1859.

46 God the Father, the Virgin and Angels (detail of pl. 44)

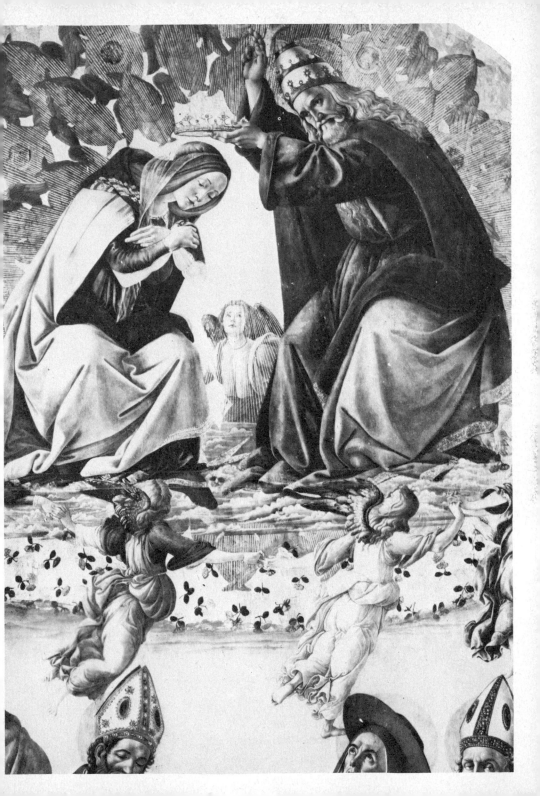

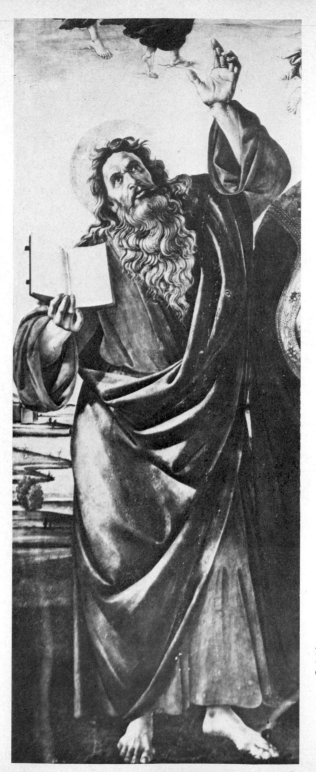

47 St John the
Evangelist (detail
of pl. 44)

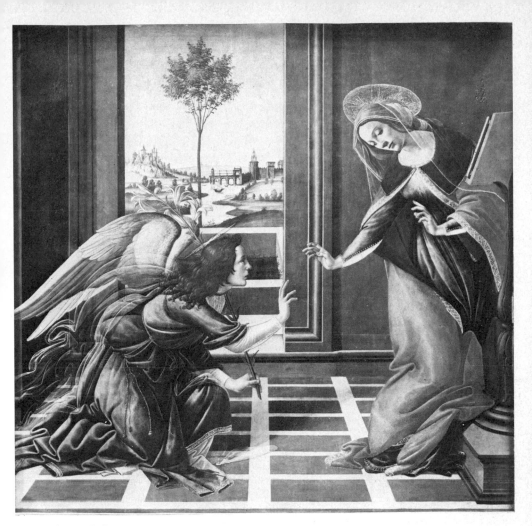

48 *Annunciation*

On close inspection it becomes apparent that many of the heads in the upper register were done by the workshop. The fact that these different contributions produce no sense of disharmony in the whole demonstrates again how easily Botticelli's style was imitated, thus making it possible for many workshop pieces to pass as being by the master's own hand.

The last altarpiece for which we have a commission was painted between 1488 and 1489 for the Guardi chapel in the church of Cestello, where it was seen by Vasari. This *Annunciation* is so different from the San Martino *Annunciation* that it has sometimes been attributed to the workshop. While the help of assistants is likely, the picture must be basically Botticelli's for it shows all the characteristics of his late style. Colour and line have become much harder; the movements of both angel and Virgin are angular and without grace. The gestures are mannered, if not stilted, and the action takes place in a bare chamber. The only warm touch is the lovely little landscape that can be glimpsed through a window in the background.

The Cestello *Annunciation* is yet another example – and perhaps not to everybody a pleasing one – of that increasing intensity and nervousness, not to say fervour, to be found in Botticelli's later religious paintings. While there are similar tendencies in the work of other Florentine painters during the last two decades of the fifteenth century, nowhere else is the transformation so stark and dramatic.

During the 1480s it was not only commissions for large altarpieces which kept Botticelli busy. Some of his most famous paintings are perhaps the smaller pictures of the Madonna and Child, which he and his workshop produced for private devotion. Indeed, his approach to this genre proved to be so appealing that his paintings were widely imitated, not only by members of his workshop, but also by lesser followers and, once Botticelli had become popular in the nineteenth century, by forgers. There certainly are more fake than genuine Botticelli *Madonnas* around, and far too many have been attributed to the master sometimes on no sounder evidence than the opinion of a dealer. Since there are no documents for any of Botticelli's genuine *Madonnas*, it is often more difficult to disprove such an attribution (particularly if the work has been sold as a 'Botticelli' and fetched a correspondingly high price) than to prove it.

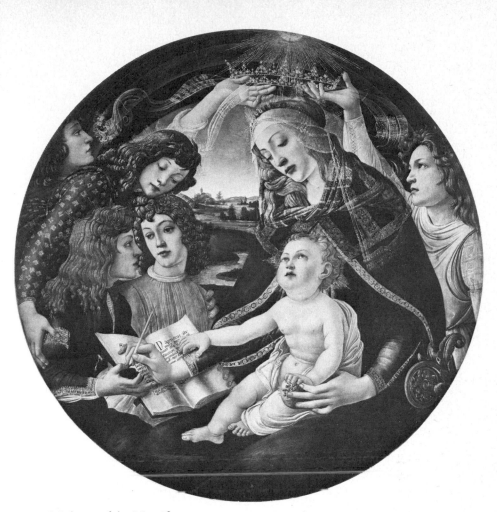

49 *Madonna of the Magnificat*

One of the paintings that can be attributed safely to Botticelli is the *Madonna of the Magnificat*, dating probably from the early 1480s. Attempts have been made to identify this picture with one mentioned by Vasari as being in San Salvatore al Monte, but for this there is no real evidence. Although somewhat restored, the painting has kept much of its original beauty. Botticelli again has used the tondo form most effectively.

49

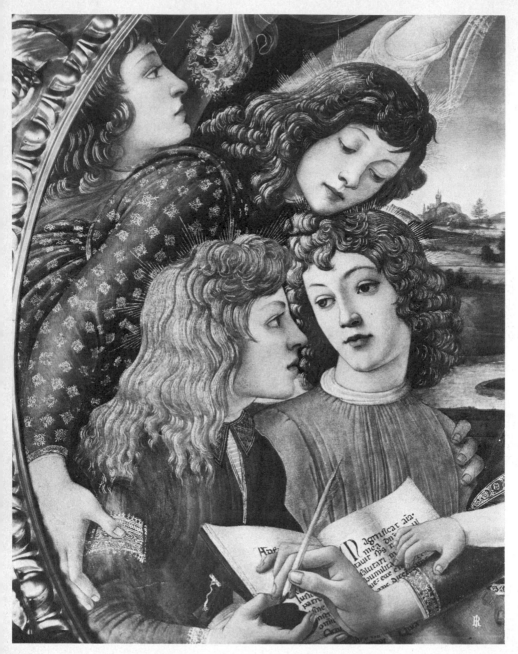

50 Angels (detail of pl. 49)

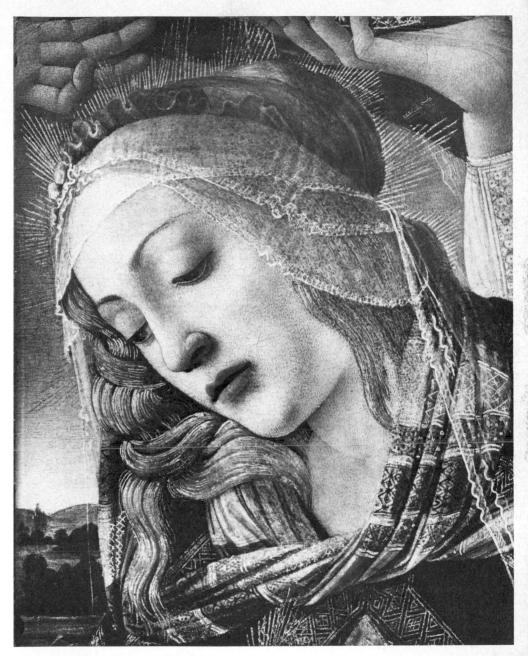

51 Head of the Virgin (detail of pl. 49)

The Virgin, surrounded by wingless angels, is about to write in a book in which she has begun her hymn of praise, the Magnificat. The Christ Child looks up to her and reaches out to

50 guide her hand as she dips a pen into an inkwell held by one of the angels. In the other hand the Child holds a pomegranate, a symbol of immortality often represented in this context. The

51 finely modelled noble features, the thick locks of beautiful golden hair, the full lips, and the delicate details of the scarf round Mary's neck, all give Botticelli a chance to display in a really splendid manner his command of line, form and colour.

But this *Madonna of the Magnificat* is not just a picture of a beautiful lady with her child. Two angels are holding above the Virgin's head a crown of stars with twelve points, and higher still appears the sun with the dove of the Holy Ghost. Round the upper edge of the tondo runs a rainbow, not represented in its true colours, but rather as an artistic convention in different shades of purple. The explanation of these symbols can be found in Revelations: 'And there appeared a great wonder in heaven; a woman clothed with the sun, and the moon under her feet, and upon her head a crown of twelve stars' (Revelations xii,1). It was common enough to identify the Virgin with the Woman of the Apocalypse and to represent her accordingly. The rainbow, another apocalyptic symbol, has replaced the moon here since the Virgin's feet cannot be seen. In many depictions of the Last Judgment Christ is shown seated on the rainbow, as for example on the thirteenth-century cupola mosaics of the Florence Baptistery, where the same colour scheme is used.

It is now realized that Renaissance renderings of the Madonna and Child are not just realistic representations of happy motherhood, as had been believed in the nineteenth century. Painters like Filippo Lippi, Ghirlandaio or Botticelli always manage to convey a feeling of human warmth in such pictures, but they nevertheless give a deeper religious significance to them. A good example of this is a generally

52 accepted earlier work by Botticelli, the *Madonna of the Eucharist* which must date from the 1470s, because the facial types of

84

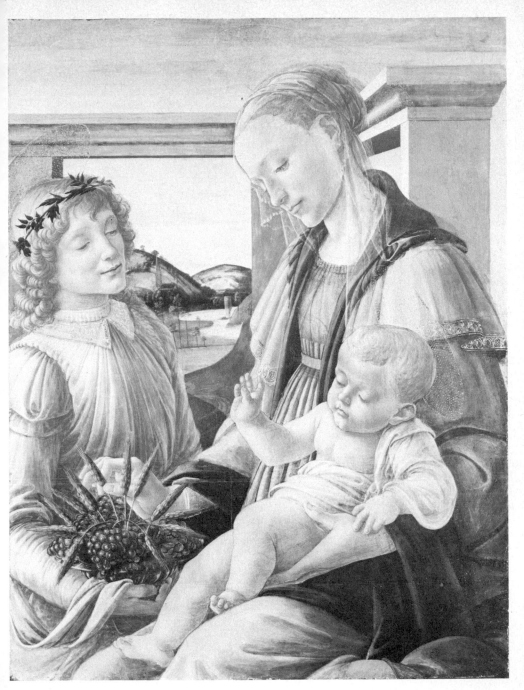

52 *Madonna of the Eucharist*

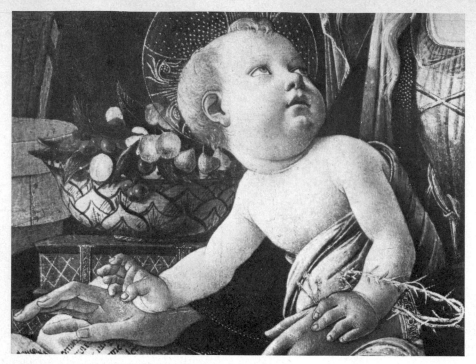

53 Christ Child (detail of pl. 54)

Virgin and angel show that Botticelli was still under the spell of
Filippo Lippi and Antonio Pollaiuolo. The Child raises His
hand blessing the wheatsheaves and grapes in front of Him, the
emblems for the bread and wine that symbolize Christ's
sacrifice.

It was normal practice to have the Christ Child playing with
something that prefigured events in His life. A work of this type
54 that must belong to the period of the *Magnificat* is the *Madonna
del Libro*, which again combines naturalism and symbolism
harmoniously. Mother and Child are seated together looking at
a book (the text of which has not been identified) and behind is a
bowl of fruit in which cherries – a symbol of the Fruit of
53 Paradise – are prominent. In His left hand the Christ Child
holds the nails of the cross and around His wrist, like a bracelet,
is the crown of thorns.

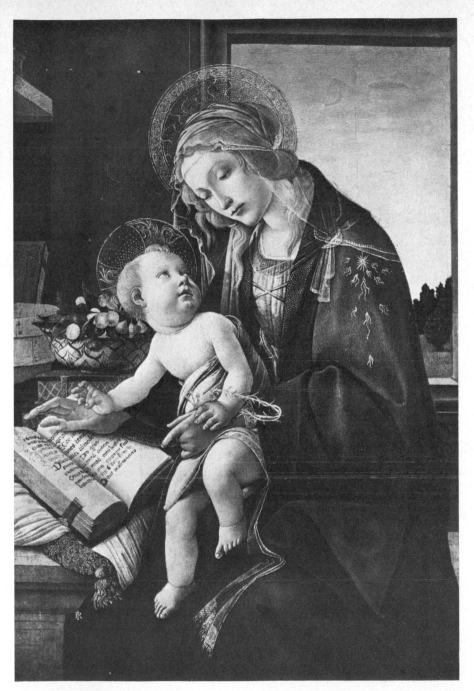

54 *Madonna del Libro*

Perhaps the best preserved of all Botticelli Madonnas is the large tondo of the *Madonna of the Pomegranate*. As with the *Magnificat* the Child holds a pomegranate in one hand but this time He raises the other in blessing. The Virgin herself holds no symbols, but the attendant angels carry a garland of red roses and lilies, signs of Mary's purity and love. This picture must have been one of the latest of its kind painted by Botticelli, for the lines are hard, the colour lacks lustre, and the composition does not answer the challenge implied by the tondo form.

55 *Madonna of the Pomegranate*

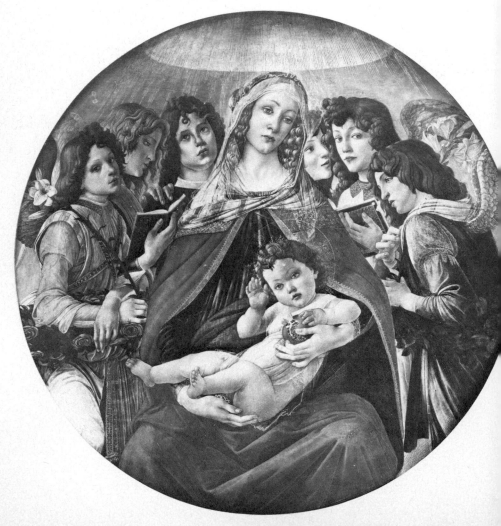

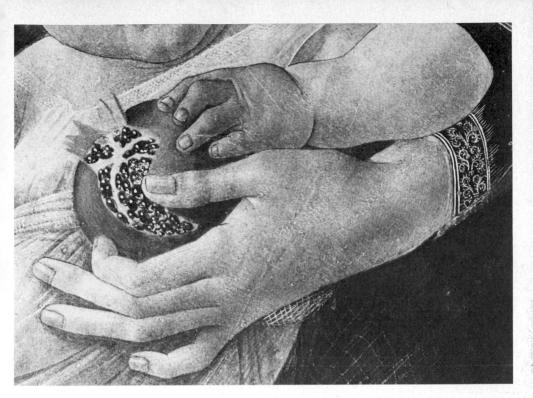

56 Hands holding the pomegranate (detail of pl. 55)

The austerity and religious intensity characteristic of Botticelli's work in the 1490s can be clearly seen in a small panel of *St Augustine in his Cell*. Gone are the loving details of the 57 scholar's cluttered study in the Ognissanti fresco, painted some ten years earlier. Now the saint confronts us sitting stiffly in an oppressive barrel-vaulted cell. He still has a bookshelf, but it is more an attribute than a piece of furniture, and the only human touch is found in the discarded quills and scraps of crumbled paper at St Augustine's feet.

This utter concentration on essentials is even more pronounced in another small picture, the *Last Communion of St* 58 *Jerome*. Authenticated through a reference in the will of its first owner, it must have been painted late in Botticelli's life. The

subject lends itself to the expression of that intense devotion which seems to have obsessed the ageing painter: Jerome, feeble and emaciated, devoutly receives the Eucharist given to the dying. His tiny cell has bare wattle walls, and the windows are nothing more than rectangular holes cut into them. The line is tight, edges are hard, colour has become muddy, and asceticism is the all-pervading mood of this moving picture.

All this points to a profound emotional disturbance and a new attitude not only to religion but also to the function of religious painting. The direct appeal to the beholder's feelings

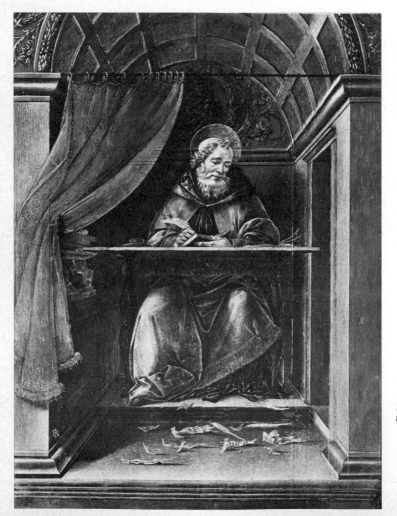

57 *St Augustine in his Cell*

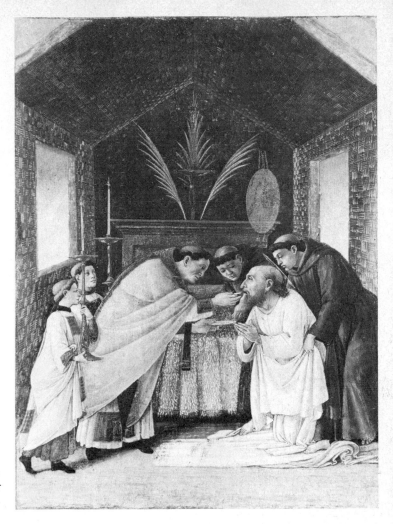

58 *Last Communion of St Jerome*

had become part of Botticelli's art, and he refashioned his artistic idiom accordingly. Vasari, it will be remembered, claims that the painter became a follower of Savonarola and was so shaken by the Prior's execution in 1498 that he never touched a brush afterwards. But this is an oversimplification, and, as we have seen, the statement that he did not paint anything after Savonarola's death is in fact untrue. But the Florence of the 1490s was a much troubled city, and one did not have to

sympathize with Savonarola's party in order to feel that the time was out of joint.

Botticelli's personal reaction to Savonarola's activities can only be surmised. While having close contacts with the Prior's sympathizers through his brother, Sandro had friends and patrons in both camps and there is no evidence that he took an active part in the power struggles which rent Florence. The religious fervour of his later paintings should therefore not be interpreted as the direct outcome of Savonarola's influence but rather as an anxious response to the uncertainties of the time. There were artists in Florence who did fall under the sway of Savonarola (e.g. Fra Bartolomeo), but others, among whom were Botticelli and Filippino Lippi, owe their taut nervous style to more general causes.

59 Head of Christ (detail of pl. 60)

60 *Lamentation*

Twice during the 1490s Botticelli treated one of the most deeply moving scenes in Christian iconography, the Lamentation over the Body of Christ. Neither painting is documented, but the attributions are almost universally accepted. It is generally assumed that the oblong panel, now in Munich 60 was the first to be painted. While knowing neither its original destination nor the exact date, we may deduce from the size and the addition of St Peter, St Paul and St Jerome to the biblical personages that this *Lamentation* must have stood on an altar.

There is a disquieting tension in this picture because of the two kinds of figures which are in dramatic contrast. The three saints retain a quiet detachment from the drama unfolding before them. On the other hand, the emotion and agony of Christ's followers are quite unrestrained and exceed every previous attempt Botticelli had made to convey strong feeling. The body of Christ hangs in a limp arc across the Virgin's lap as

she collapses in a dead faint into the arms of St John the Evangelist. The Magdalen, her face torn by grief, clasps the feet of Christ. Mary and Martha in deep sorrow are at His side, the one holding His head, the other showing the nails used on the cross. These actions and expressions speak a strong language, which is reinforced by the nervous lines of cloaks and veils and the freely falling loose hair of the women. But it is the body of Christ that is the most striking element of all. The strong backward bend, the stiffness of the limbs and the drooping head convey the torment and agony of His death. Another unusual feature is that Christ is shown beardless with a face rather like a young Greek god. The huge stones framing the blackness of the cave behind the group press in on the figures, increasing the unbearable tension. Truly this *Lamentation* is one of Botticelli's most compelling renderings of deep religious feeling.

The second version of the *Lamentation* is mentioned by Vasari, who saw the painting in the church of S. Maria Maggiore in Florence. This time Joseph of Arimathea is present, but there are no additional saints and the picture is upright instead of oblong. The figures, to fit in with the shape of the

61 Head of the Virgin (detail of pl. 62)

62 *Lamentation*

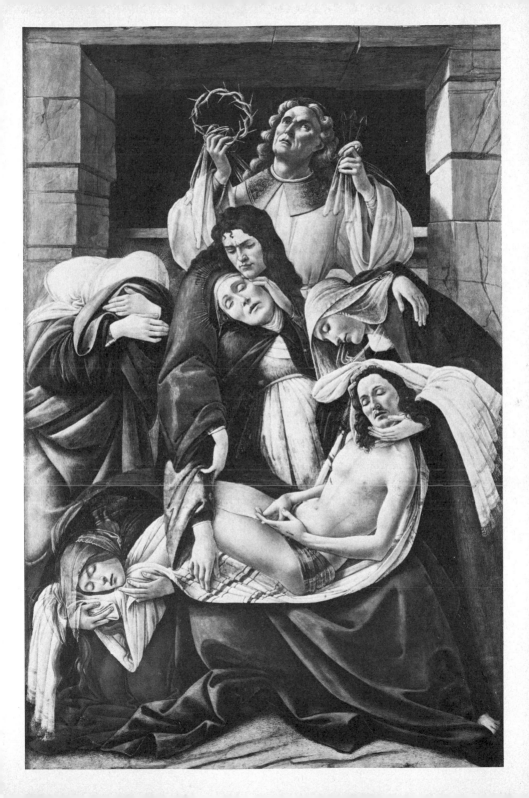

panel, have been arranged in a pyramid with Joseph of Arimathea at the apex, looking upward, holding the crown of thorns and the nails. Again the Virgin faints and sinks into the arms of St John, but the intensity of the earlier *Lamentation* is lost, mainly because of the awkward pose of Christ, who is propped up in His mother's lap with His hands clasped over His stomach. Though gestures and expressions are less strong, there is an even greater tightness of linear design, the outlines are harder, and the colours harsh.

Botticelli's personal involvement with the stark feelings evoked by these pictures cannot be questioned, for the alteration from his earlier manner is too marked to be simply put down to a 'change in style'. The depicting of such helpless grief had been unknown in Florentine Quattrocento painting (though it was familiar enough in Flemish and German art). Even allowing for the increase of emotion in art at the end of the century, no other artist revealed the degree of naked feeling as did Botticelli. *Lamentations* by, say, Perugino, look lifeless by the side of Sandro's and only Filippino reveals at times a similar fervour.

In the year 1500 Botticelli painted his only signed and dated picture, the so-called *Mystic Nativity*. Its central feature is indeed a traditional Nativity scene with the Virgin kneeling in adoration of her Child under a lean-to roof, St Joseph sitting to the side. The wooden structure of this very simple shed is built against a rock with an entrance into a cave directly behind the Virgin. The detailed narration of St Luke only speaks of a stable, but apocryphal accounts of Christ's birth claimed the manger had stood in a cave, and this version found its way via Byzantine art into the West. The symbolic significance of the cave as link between Christ's birth and burial, with the implied promise of Resurrection can easily be grasped. Such inclusion of the cave in Nativity scenes was not common in Florentine art, but the relevance of this symbol in the case of Botticelli's *Mystic Nativity* becomes obvious once the artist's message is understood.

96

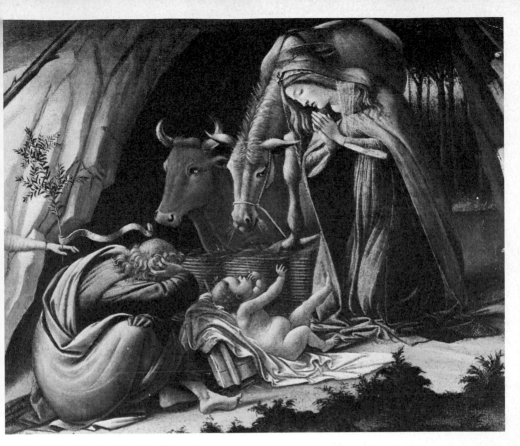

63 Holy Family (detail of pl. 41)

To the left of the stable angels are leading forward three men, who can only be the Magi, and to the right the shepherds are approaching, also accompanied by angels. All are crowned with olive wreaths. On the roof of the shed three angels are singing and the sky is alive with a circle of dancing angels under the golden dome of the open heavens. This iconography is hardly unusual but the pictorial treatment is of a peculiar kind, considering the date of this painting. There is no clear definition of space nor any uniform treatment of scale. This in fact varies in accordance with the religious significance of the figures. The Virgin is larger than any of the others. Joseph is a good deal

64, 66

97

smaller, and the shepherds are only slightly larger than the Holy Child. Such handling can only be the result of a conscious regression from the principles of fifteenth-century realistic narrative and a turning back to practices found in medieval art.

But there are also elements which are unique to this Nativity. In front of the manger three angels embrace three men, again crowned with olive branches, and little devils are scuttling in all directions, disappearing into the ground like rabbits into their holes. Inscriptions on small streamers, though now difficult to decipher, contain the well-known angelic message from Luke: 'Glory to God in the Highest, and on earth peace and good will towards men.' It is this promise of peace which Botticelli has made into a joyful image. The angels greet the three men, representatives of all mankind, quite literally with the 'kiss of peace', a well-known Christian convention, often shown in representations of Paradise. The dancing angels in the sky carry crowns and streamers which taken together seem to contain a hymn to the Virgin. Images and words combine to one glorious praise of peace coming to the world with the birth of Christ.

The strangest feature, however, is the Greek text written in two lines across the top of the painting which some learned friend must have translated for Botticelli. Since it contains a mystic prophecy the disguise in a language not accessible to everyone is not surprising. Rendered into English it reads: 'This picture, at the end of the year 1500, in the troubles of Italy, I Alessandro painted, in the half time after the time, at the time of the fulfilment of the 11th of St John in the second woe of the Apocalypse, in the loosing of the devil for three and a half years. Then shall he be chained according to the 12th and we shall see . . . as in this picture.'

The text is obscure enough and our understanding of it is further hampered because of an illegible word near the end which is of vital importance to the unriddling of the message. Because most art historians have been obsessed with the idea of Botticelli as a Savonarolan, their attempts at interpretation have involved elaborate linguistic gymnastics to suit the words to this

65

98

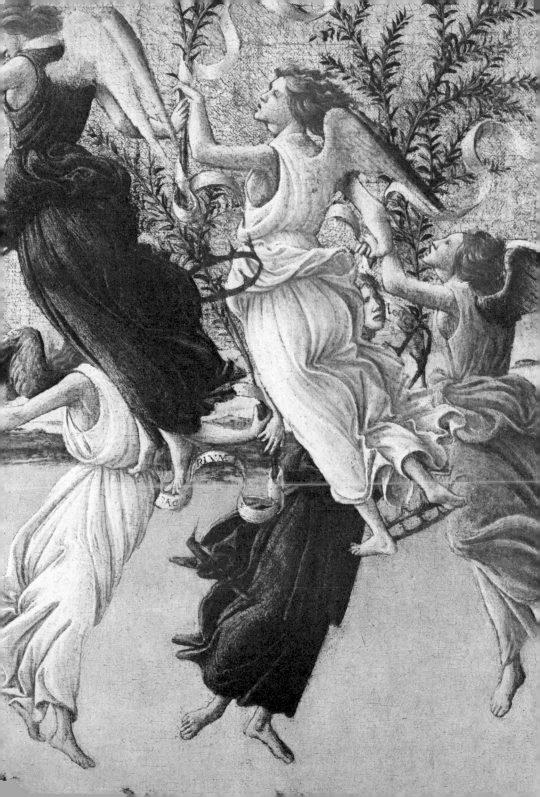

idea. Not only are there many calculations of months between events in the friar's life and the painting of this picture, but the illegible word has been filled in by words appropriate to the particular interpretation.

We are told in the opening phrase that this picture was painted at the end of the year 1500. Since the Florentine year ended on 23 March, the painting must have been finished sometime during the first three months of 1501 according to our reckoning. In 'signing' the Nativity, Botticelli uses the first person singular – 'I Alessandro painted' – instead of the common third person, and there is no reference to any patron. We may therefore conclude that he made this picture for himself and on his own initiative.

The phrase 'in the time after the half time' seems puzzling at first. It echoes a similarly dark phrase used in the Book of Daniel and in the Apocalypse, but there we read: 'time and times and half-time.' Botticelli's phrase looks more precise and can only refer to the chiliastic expectations of his day. The millennium which had not come in the year 1000 was widely expected to arrive half a millennium later in the year 1500, which is exactly what Botticelli says.

'The troubles of Italy' referred to though not specified by Botticelli, must have heightened the sense of expectancy. As already mentioned, they were many and it needed no Savonarola to remind the Florentines what they were. The references to the eleventh and twelfth chapters of Revelations underscores the apocalyptic nature of the inscription and the mentioning of the 'second woe' makes it into a definite prophecy. For if, as Botticelli states, his picture was painted 'in the second woe of the Apocalypse', it dates from a period which, according to the Scriptures, will immediately precede the coming of the millennium. In this context the Apocalypse does refer to 'the loosing of the devil for forty-two months' (which is three and a half years) and to his final chaining, but in fact Satan is not chained in Botticelli's picture. Instead many small devils are fleeing underground as Christ is born. The

65 Angels (detail of pl. 4

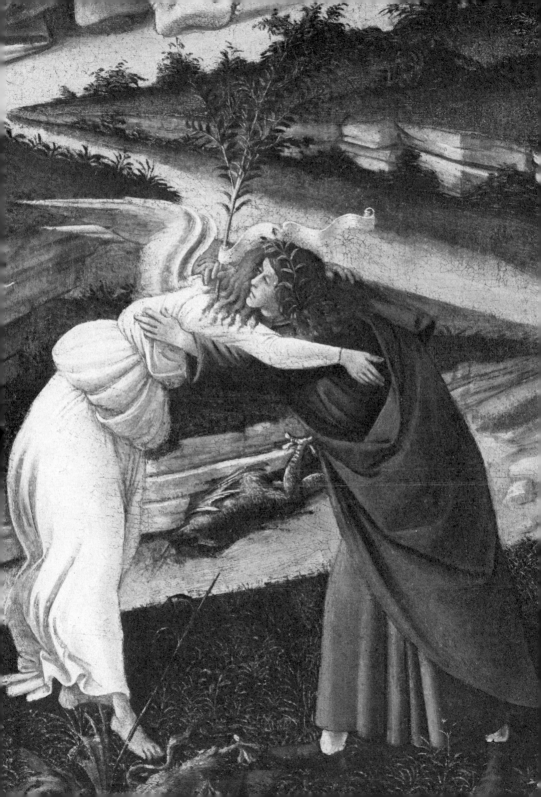

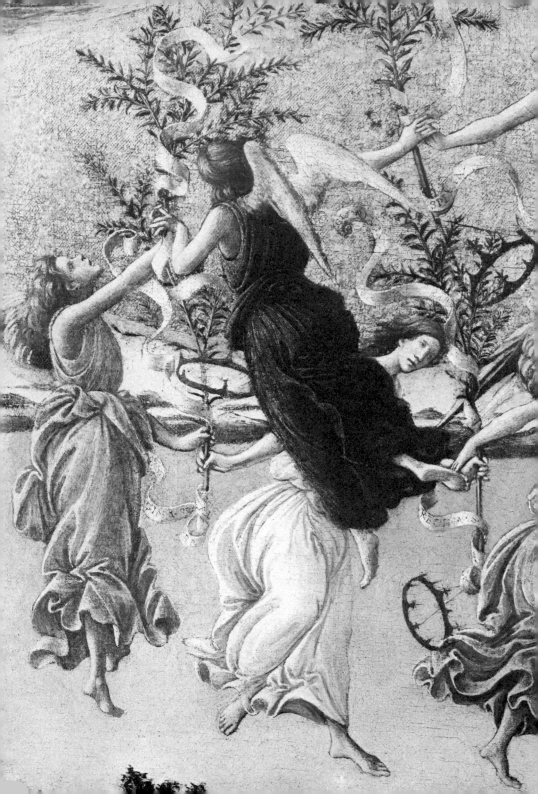

missing verb near the end of the Greek text must therefore have referred to the symbolic significance of His birth.

In short, the *Mystic Nativity* fits well into the general framework of chiliastic hopes we discussed a little earlier, and there is no need to indulge in complicated sums in order to explain Botticelli's clumsy text. Savonarola was not burnt three and a half years before the winter of 1501, nor did Charles VIII invade Italy forty-two months before Botticelli took up his brush to paint his *Mystic Nativity*. The power of this painting and its compelling mood rest on the fact that of his own volition the artist expresses widespread religious hopes without descending to the world of the sordid politics of the day.

However, another picture dealing with millennial beliefs is of a decidedly political nature. Unfortunately it is in a very bad condition, and while its style is unmistakably Botticellesque, it is impossible to be sure that it is entirely by his hand. The *Mystic Crucifixion*, as it is usually called, is an allegory of Florence and her ordeal before becoming the New Jerusalem. 42, 68

The painting is divided into two halves by the huge cross on which Christ has been crucified. To the right are scenes of wrath and punishment. Clouds of smoke fill the sky and devils are hurling down firebrands. In the foreground an angel holds up and whips a small animal resembling the Florentine emblem lion, the marzocco. This must be the Whip of God – the *flagellum Dei* – promised by Savonarola and other preachers which the Florentines must suffer before they can arise purified and holy.

To the left of the cross are scenes of repentance and salvation. The beautiful woman clinging to the foot of the cross is not only the penitent Magdalen (who frequently appears in this position), but also a personification of the city of Florence, which in poetry was often likened to a 'Bella Donna'. A wolf slinks away from under her cloak, perhaps an allusion to the corrupt Church (another target of contemporary preachers). This particular symbol had first been used by Dante in his

67 The city of Florence (detail of pl. 68)

67 attacks on Rome. Florence, easily identified by the cupola of the cathedral, is bathed in pure light, ready to assume her role as the New Jerusalem. God, seated in a glory of Cherubim above the town, rains down white shields with red crosses, the symbol of Florentine Guelphism, to save the city from the approaching conflagration. (In the rivalry between pope and emperor, the Guelph party supported the pope, the Ghibelline the emperor.)

 The message contained in this picture is clearly directed at the Florentines, and all in all we see their city in three phases of her 'history': scourged, repentant, and finally triumphant under God. Though this imagery reflects fears and expectations of the

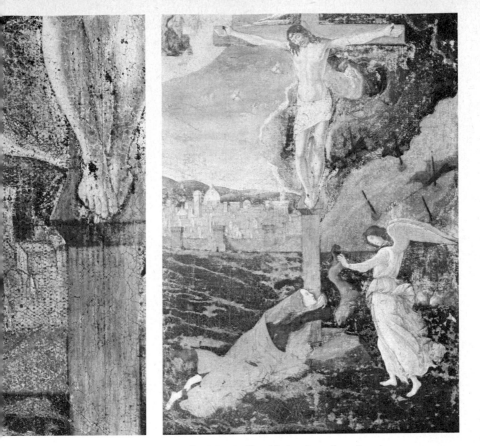

68 *The Mystic Crucifixion* (see also pl. 42)

time, it is not inspired by any particular one of Savonarola's sermons, but rather by concepts which had been widespread throughout the fifteenth century. Millennial prophecies, which had been of little importance when the times were good, suddenly became meaningful when they were bad.

Perhaps the last of Botticelli's works known to us are the four panels showing the story of St Zenobius, painted for the Compagnia di San Zenobio, one of the many religious confraternities thriving in Florence. The oblong shape of the panels makes it likely that they were used as decoration for furniture, probably in the meeting room of the Compagnia.

69–73

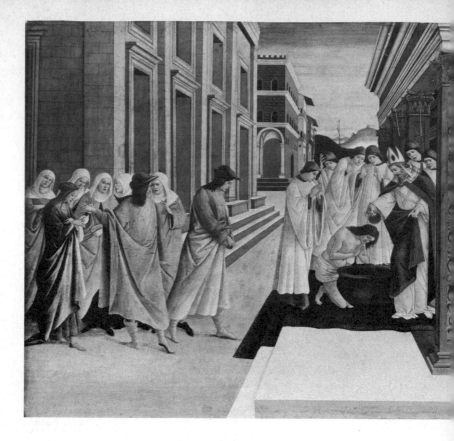

St Zenobius, one of the patron saints of Florence, had been a wealthy young Florentine who renounced his fortune, converted to Christianity, eventually became bishop of his native city, and performed many miracles. Each panel contains several incidents from his life.

From the standpoint of the pictorial conventions of the early Renaissance the idiom employed in these panels is an anomaly. The scenes on each panel are not held together by some compositional device (as in the Sistine Chapel) but they are simply set side by side. This manner of narrative derives from the medieval tradition of telling a story in pictures and the whole effect is very much like that of a comic strip.

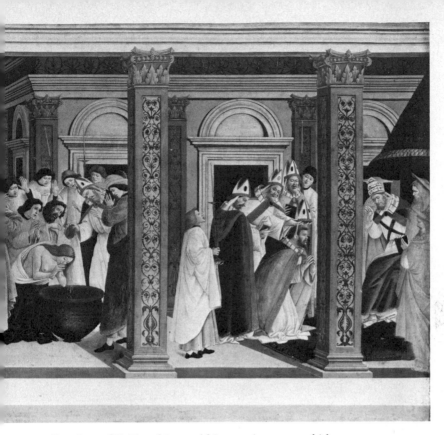

69 Baptism of St Zenobius and his appointment as bishop

Botticelli's late style, as it appears here, has crystallized. The figures are elongated, their outlines are hard, and there is little modelling. Draperies are brittle and lifeless. The sterility of the setting is emphasized by the flat cardboard-like buildings resembling the sets of a toy stage. The tight nervousness which was a mark of the paintings of the 1490s has turned into an archaic and unpleasant primitivism which must have looked strange in a town becoming familiar with the art of Leonardo, Fra Bartolomeo and the young Michelangelo.

Despite this obvious deterioration during his last years Botticelli was one of the outstanding religious painters of his day. His deep sensitivity, his characterization of the personalities

he painted, and his inborn ability to illustrate a story, can be readily seen in his output up to the early 1490s. It is only with the apparent increasing religious fervour on the one hand, and the decline brought about by old age on the other, that his clarity and skill become clouded and are replaced by involved mystical images of his own creation. Although his popularity declined rapidly after 1500, he had been the most widely imitated artist in Florence. Obviously his style was not to Vasari's taste and he remained forgotten until the nineteenth century when his art was rediscovered, his fame re-established, and his works remanufactured.

70 Child restored to its mother (detail of pl. 73)

71 St Zenobius casts out devils and restores a child to life

72 St Zenobius restores the sick and raises the dead

73 St Zenobius restores a child crushed by a cart, and the death of St Zenobius

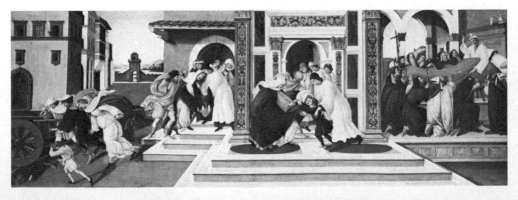

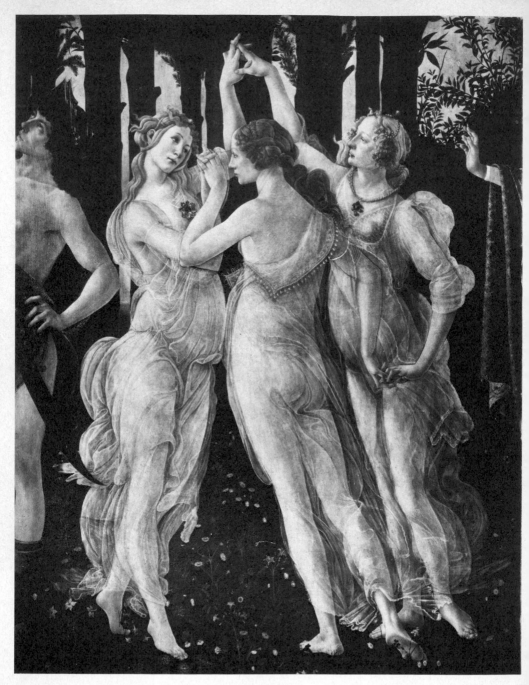

74 The Three Graces (detail of pl. 82)

Allegories and Mythologies

AS WE READ THROUGH Vasari's life of Botticelli, we encounter far fewer secular paintings than religious ones. This is hardly surprising. When Florentine patrons of the Quattrocento commissioned a large work of art it usually involved a religious subject. The taste for secular decorations was met by Flemish tapestries often illustrating Romances or medieval tales, and by chests, overmantels and other furnishings painted with scenes from such writers as Boccaccio or Livy who could tell a good story with a moral attached to it. Yet even where the subject matter was classical, the style of such pictures certainly was not. Heroes and heroines were dressed in the height of contemporary fashion, usually in the French style, and the lively realistic narrative was enhanced by the bright colours and rich decorative surfaces of International Gothic. There is no evidence for large independent paintings of classical deities before the 1470s, and Botticelli's *Primavera* is in fact the first example of an entirely new type of picture in the fifteenth century.

Still, it would hardly be appropriate to make Botticelli into a propagandist for some alleged 'pagan revival' as a result of the *Primavera*, the *Birth of Venus*, or the *Pallas and the Centaur*. While it is true that these 'mythologies' are larger in scale than previous depictions of classical subjects and that they are not furniture paintings but pictures intended to be hung on a wall, they cannot compare in monumentality with works like the *S. Barnaba Altarpiece* or the *Coronation of the Virgin*. What is more important, religious works were not abandoned for pagan topics and although Botticelli used the same figure types in both, he never attempted the intensity of feeling in his 'mythologies' that he strove for with his religious works.

Another significant aspect of Botticelli's secular art is often overlooked. The larger religious paintings, commissioned by confraternities, guilds, or individual patrons, were meant to serve public worship in churches or chapels, and the smaller ones, notably the Madonnas, were painted for private devotion. But whatever their final destination, they all conformed to current Christian beliefs so that any worshipper could understand their message immediately. Even the *Mystic Nativity*, with its Greek inscription and additional figures, is not really an exception because the central scene remains clear and traditional. But the 'mythologies' and allegories were not for public display nor did they conform to a fixed set of beliefs. These works were painted for specific patrons and were hung in private residences, as can be seen from various contemporary inventories which have survived.

82 Today the *Primavera* may be one of the chief attractions of the Uffizi, besieged by puzzled crowds of gaping sightseers, but in Botticelli's day only the owner, his family and friends would have seen and admired this painting in the quiet atmosphere of a home, and they would have known (or been told) what it was meant to represent. The artist had been instructed in some detail what he was to paint, as was normal practice, because the taste and personal interests of the patron determined a commission. This is precisely why it is so difficult for us to comprehend the symbolism of the *Primavera* and similar pictures. Each one was, so to speak, 'made to measure'. Their formal qualities may be enjoyed without asking about their iconography, but unless we attempt to define the intellectual world of the patron we cannot expect to understand their content. Once such a context is established these pictures can reveal something of the outlook of their erstwhile owners, but not more. They must not be called products of 'the spirit of the age', a meaningless phrase for something which does not exist, nor should they be degraded by being made representatives of an alleged Renaissance of paganism. History and art are made by people, and abstract blanket terms distort both, especially in so rich and complex an

age as the Quattrocento. From the religious paintings of the time a good deal about the beliefs of society can be inferred because Christianity was and remained the universal creed for Europe. In contrast, secular painting, as it became more fashionable, reflected the tastes of smaller groups within the broader stratum of society. The *Primavera* or the *Birth of Venus* tell us at best a little about the predilections – artistic and intellectual – of a small circle living in one Italian town of approximately 100,000 inhabitants. Of that population, few had sufficient erudition or concern to appreciate the *Primavera* and even fewer were likely to see it. Hence patrons and painters could indulge the whims and fancies of their private world in a manner which would be unthinkable with religious art.

As already pointed out, one place where people enjoyed pictures of classical mythology, ancient history or modern tales was on their furniture. Wedding chests (*cassoni*) were great favourites in Florence. Usually produced in pairs, these were sumptuously adorned and such was the demand that there were special workshops which produced them in large numbers, though some must have been designed by leading masters. Vasari mentions only one set of *cassone* paintings from **75–** Botticelli's workshop, the four panels decorated with the story **78** of Nastagio degli Onesti, made in 1483 on the occasion of the wedding between Gianozzo Pucci and Lucrezia de Piero Bini. These panels decorated the front and rear of two chests; the decorations from the shorter ends do not survive.

The story is from Boccaccio's *Decamerone* (V, 8). It tells how a young man, Nastagio, finally won the love of a young lady by showing her the horrible fate which befell a girl who refused to marry her suitor. The first panel shows Nastagio, while **75** dejectedly walking in a forest, meeting a damsel pursued by a knight and his hounds. The second panel shows her **76** disembowelled by the knight and her subsequent miraculous recovery. The knight explains to Nastagio that this chase will go on forever because the lady was condemned to suffer this fate for rejecting his love. On the third panel Nastagio brings his **77**

113

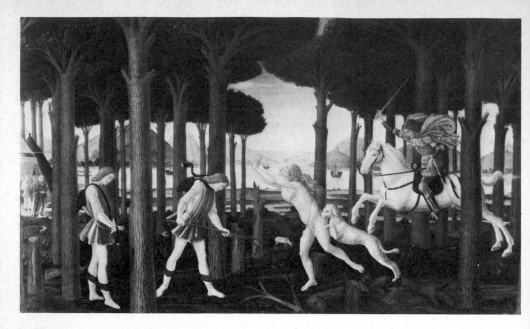

75, 76 *The story of Nastagio degli Onesti*: Nastagio sees a lady (above) pursued by a knight, and (below) disembowelled

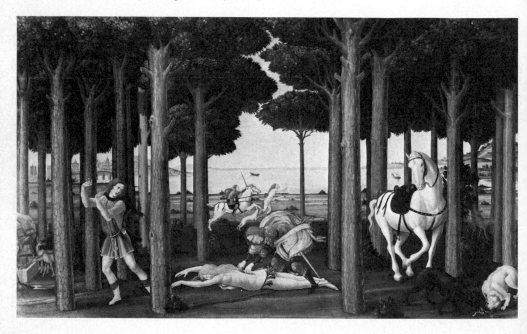

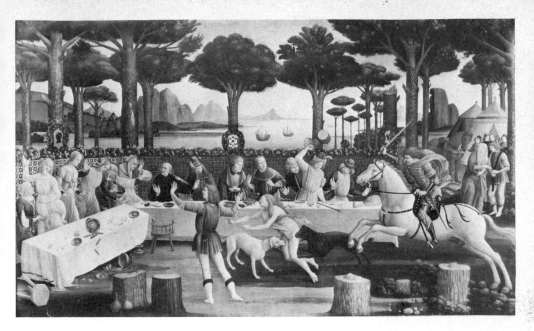

77, 78 Nastagio (above) gives a banquet in the forest to show his guests the lady and the knight, and (below) is married

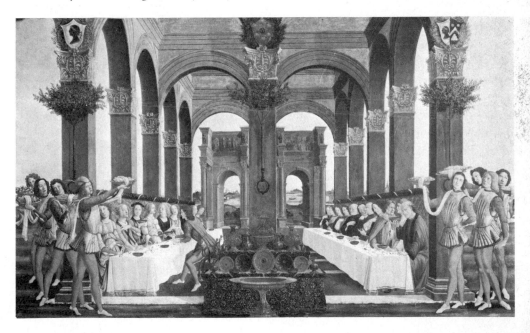

115

lady and her family to the forest to let them see the horrible fate
78 which might also await her. The last panel shows that the device
worked, and a great wedding banquet is in progress. Since the
Medici had arranged the marriage, their arms together with
those of the Pucci and Bini are prominently displayed.

We may find it hard to understand why this gruesome, even
disgusting, tale should appear on a wedding present. But we
must not impose our standards on the fifteenth century. The
moral of this story was simple and obvious to any man or
woman in Botticelli's Florence. A girl rejected marriage at her
peril and it was her duty to accept the husband who had been
chosen for her. There were other stories used in the same
manner – the equally unwholesome fate of Griselda, as told by
Boccaccio for example – which give us a curious insight into the
social life of the period.

In style these panels are not remarkable, and they conform to
the general idiom employed by *cassone*-painters. They are
descriptive, lively and explicit in details. The best is certainly the

79 *The story of Virginia*

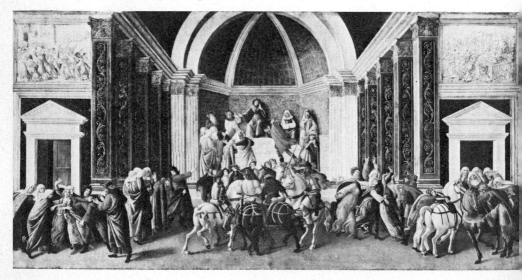

116

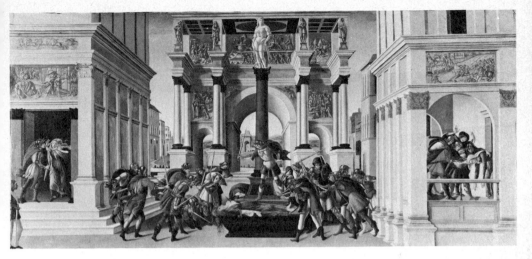

80 *The story of Lucretia*

last one, the sumptuous wedding feast with many guests
assembled round a horseshoe table in front of a triumphal arch
which was often included in the ephemeral decorations of such
occasions.

Two other panels attributed to Botticelli's workshop are also
characteristic of their kind. They illustrate moral examples
from early Roman history, but they are too large to come from
cassoni, and it has therefore been suggested that they were
overmantels or headboards for beds. On one of them the story *79*
of Virginia is depicted in seven episodes showing how a Roman
father preferred to kill his daughter rather than let her be
dishonoured. The other, showing the story of Lucretia, has only *80*
three episodes: the rape, Lucretia's suicide, and her father's oath
of revenge. The handling in both pictures is coarse, and
Botticelli himself can have done little more than furnish the
designs.

Both stories, in order to give them an authentic ring, are
enacted before an elaborate pseudo-classical setting, but the
handling of architecture and of space and perspective are far

inferior to anything we normally find on Botticelli's paintings. These panels are therefore less interesting for artistic reasons than for the insight they give us into Florentine workshop practices of the time. In the case of lesser works, such as furniture paintings, the master himself would only make the design, but details and execution were left in the hands of assistants who – as in this case – were sometimes barely competent. But there may also be another explanation for the poor quality of these paintings. They could have been manufactured by a furniture-painter who was an admirer and not very successful imitator of Botticelli. Since these two panels are neither specifically documented nor mentioned in any of our early sources, the question cannot be decided.

It must also be mentioned that the ragged style of the Lucretia panel has sometimes been explained by giving it a very late date, and it has been claimed that this allegedly republican story – Lucretia's father Brutus drove out Tarquin, the last of the Roman kings – was painted by Botticelli in celebration of the fall of the Medici in 1494. This is blatant nonsense. The Lucretia story was always read as a moral tale speaking of a woman's self-respect and of the defence of her honour. It never raises – in Livy or in any Renaissance commentator – the issue of tyranny or republic. Moreover, allusive political allegories of this kind were unknown in the fifteenth century and they belong to a later age.

None of Botticelli's paintings with mythological figures are straightforward illustrations of a classical text, and a great deal of ink has been spilled over their interpretations. None has *82* received more attention than the *Primavera* or *Spring*. This beautiful work has tempted the ingenuity of writers and scholars for over a hundred years, all of whom have tried to explain it, provide each figure with a name and significance, and to indicate the literary sources from which it all comes. It has been suggested that it represents the realm of Venus, some kind of Judgment of Paris, a rustic calendar painted for a farmhouse, a Neo-Platonic allegory, or – descending to the ludicrous – a

Wagnerian pantomime enacted in memory of the murdered Giuliano de' Medici and his beloved Simonetta Vespucci with the Germanic Norns disguised as the Mediterranean Graces. The central figure has been described as consumptive, pregnant, smiling, frowning, sad, laughing, blessing or dancing. The simple fact is that we can only suggest the 'meaning' of the picture and we cannot identify with certainty every figure.

No such problems existed for Vasari who simply said that the picture represents 'Venus, whom the Graces deck with flowers, denoting spring'. He saw the *Primavera* at Castello, a Medici villa, which had been bought in 1477 for Lorenzo di Pierfrancesco, a cousin once removed of Lorenzo il Magnifico. It is generally assumed, with good reason, that the painting was commissioned by or for him about the time of the acquisition of the villa. Although Lorenzo would only have been fourteen or fifteen, he had been carefully educated by some of the finest scholars from the circle of il Magnifico. Marsilio Ficino, the leading Neo-Platonist philosopher of the time, was one of his mentors and Poliziano, the finest poet in Florence, was among his friends. Some fifteen years later Lorenzo commissioned from Botticelli a set of illustrations for Dante's *Divina Commedia*.

The *Primavera* is the first post-antique painting which depicts classical deities almost life-sized, although there is not a single figure which derives directly from a classical model. The picture is equally perplexing in the context of late Quattrocento art because there is a remarkable absence of artistic devices generally associated with Florentine painting. Botticelli's stage is made unusually narrow by a backdrop of orange trees and there is less interest in perspective display than in other of his works of the same period. In fact, the *Primavera* suggests the sophisticated and artificial world of medieval romance rather than the more robust and solid world of Greek gods. The figures move parallel to the picture plane, with more emphasis placed on line than on modelling. Venus, standing in the centre,

is fully clothed and has the proportions of an elongated late Gothic figure. The three Graces do not resemble the famous classical group (which was known) in which they are nude and standing still. None of the figures move freely in space but appear rather to be interwoven with the rich vegetation of the setting. The ground resembles a carpet rather than a flower-decked meadow and there is nothing but flat blue sky behind the orange trees. The overall effect is very much like that of one of the Flemish tapestries, often portraying medieval allegories, which were then popular in Florence. This impression is heightened by the bulge in Venus's belly – mistakenly taken for an indication of pregnancy by some writers – which is a conventional feature in the full-length portrayal of women in Flemish art of the fifteenth century.

74 It would be wrong to say that there are no classical elements whatsoever in the figures of this work. The Graces conform to a description given by the Roman philosopher Seneca of a rendering of the group. This passage had been used by the humanist architect and theorist, Leonbattista Alberti, who recommended the subject as a topic in his treatise *On Painting* of *c.* 1435: 'those three sisters with their hands entwined, laughing and clad in ungirt diaphanous garments.' But the treatment of the hair all tricked with pearls is much closer to the contemporary style than to any classical goddess. Mercury too has only slender links with ancient art. His winged shoes – so often misrepresented in medieval art – must have been taken from a visual source which showed them correctly. A set of 'Tarocchi' cards appeared in Northern Italy some years before Botticelli painted the *Primavera*, and it has been shown that the anonymous designer of these engravings did in fact know a drawing after an archaic Greek relief. That Botticelli used this engraving for inspiration can be further seen from the close similarities in the drapery. In spite of this second-hand 'classical' source, however, Mercury still does not achieve his full ancient glory, for his helmet lacks wings, but his caduceus is entwined by winged dragons.

81 Venus (detail of pl. 82)

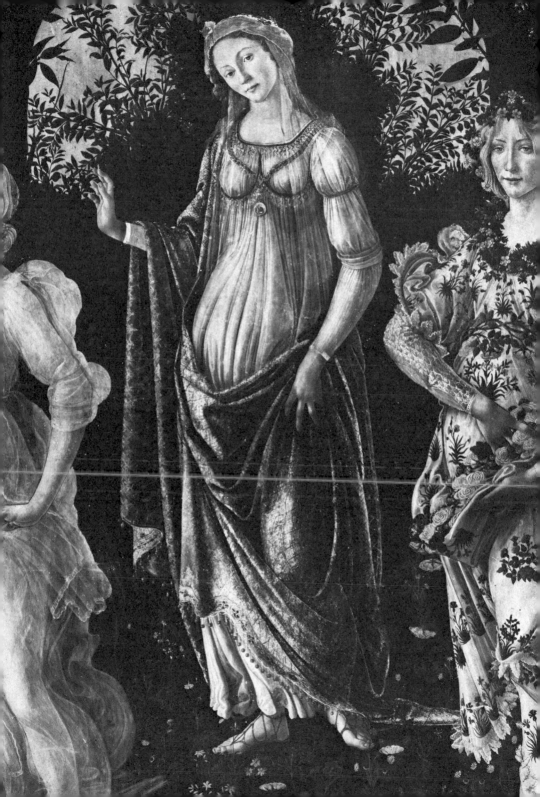

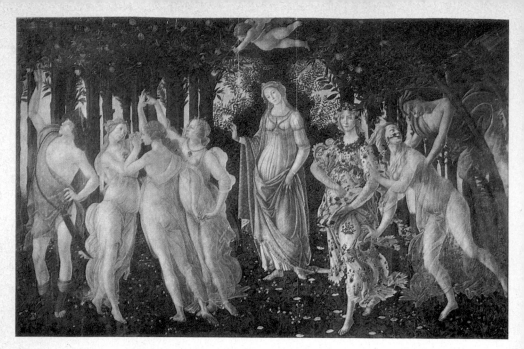

82 *Primavera*

The *Primavera* also seems closer to a late medieval tapestry than to a contemporary Italian painting or an imitation of ancient art because Botticelli has not employed any narrative technique to give cohesion to a large painting with many figures. Only on the right has he portrayed an actual incident from Greek legend which involves three figures, but there is no attempt to relate this to the others who remain isolated with no visible interaction. Even the dancing Graces are a self-contained group. Nor has Botticelli followed the model of a *sacra conversazione* with a central emphasized figure symmetrically flanked right and left by other figures. Venus is placed slightly to the right of centre and the two halves of the picture are rather different in construction. The elements making up the painting are simply set side by side like pearls on a string.

As to the personalities depicted, the left side is fairly clear. The first figure is Mercury, who lifts his staff into some wisps of

83 Venus, Flora, Chloris and Zephyr (detail of pl. 82)

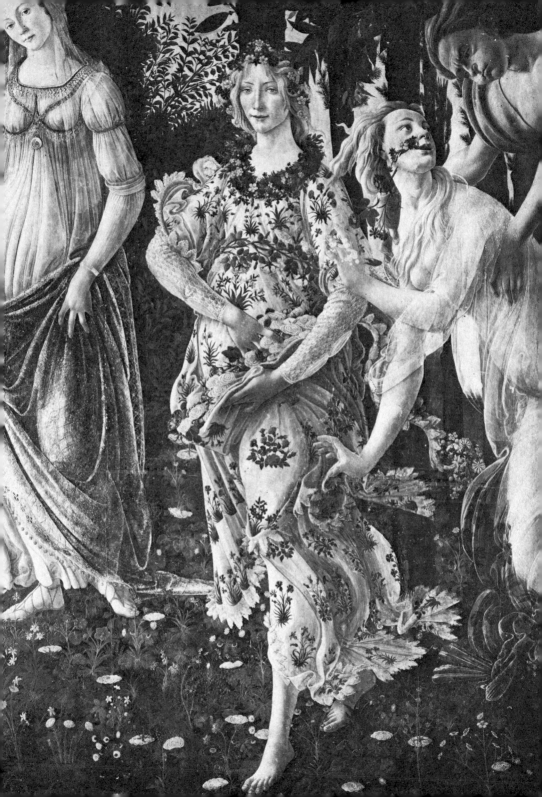

clouds which have gathered over his head, today barely visible under the layer of dirt which has collected on the surface of the

74 painting. Next come the dancing Graces in their transparent dresses. The central figure, placed a little back in a bower of

81 myrtle, is generally accepted as Venus, and although she is fully clothed, unlike antique representations of the goddess, there is little reason to question this identification, particularly in the light of the medieval tradition of showing Venus draped. Moreover, blindfolded Cupid shooting a flaming arrow hovers directly above her.

But it is not so easy to name the characters on the right half of Botticelli's painting, and much discussion has gone on over

83 their identity. The beautiful female in a flowery dress next to Venus has been called Flora, Spring and Hora. The girl next to her with flowers issuing from her mouth has also been called Flora and Spring, but sometimes Chloris. All these names are used in classical poetry for various nymphs connected with the spring season.

Perhaps these suggestions can be reconciled. The bluish figure on the extreme right blowing out his cheeks and flying through the air is normally identified as Zephyr, the West Wind, a harbinger of Spring. He is obviously pursuing the scantily clad girl in front of him, the only bit of explicit narrative in the whole picture. Its source may offer a clue to the 'meaning' of the *Primavera*.

In the fifth book of his *Fasti*, a poetic calendar, Ovid describes the month of May. Right at the beginning he tells the story of Flora, whose feast, the Floralia, was celebrated during the last days of April and the first four days of May. To explain its origin, he relates how Chloris, a nymph of the fields, was chased by Zephyr and, on his touch, changed into the more splendid Flora, nymph of flowers. There can be hardly any doubt that Botticelli illustrated this incident on the right half of the picture. The flowers issuing from the mouth of Chloris melt into the dress of Flora which in turn melts into the flowers on the meadow, linking the two figures visually.

124

Such an imaginative translation of a verbal description into a deceptively simple image is characteristic of Botticelli's power of invention.

But there is more in Ovid's account in the *Fasti* than a text for the Chloris-Flora transformation. When Flora became the wife of Zephyr, she was also made the mistress of flowers and a goddess of spring. In her honour the Graces bind wreaths of flowers and the Floralia were days of joy and dancing. In her role as mistress of spring Flora remained known to the Middle Ages and the Renaissance. Not only does she appear as such in the *Roman de la Rose*, but she was celebrated in the poems of Poliziano and Lorenzo il Magnifico who identified her with Primavera, the personification of spring. Summing up the interpretations of her role, Cesare Ripa in his *Iconologia*, written late in the sixteenth century, said: 'Flora is painted as Spring, crowned with flowers, of which also her hands are full.' As symbol of spring she enjoyed greater popularity than Venus. It seems therefore likely that Botticelli's *Primavera* was named after Flora-Primavera rather than after Venus, although the latter stands towards the middle of the painting and is also a spring goddess.

Ovid does not mention either Venus or Mercury in his text, but this does not make the passage from the *Fasti* less important for Botticelli's picture. When setting up allegories Renaissance painters and patrons rarely followed one text or illustrated it literally. They rather chose texts which explained certain concepts from which they built up their compositions. Such must have been the case for the *Primavera*, for neither Venus nor Mercury is a stranger to the company described by Ovid at the beginning of the fifth book of the *Fasti*. From classical times through the Middle Ages the Graces belonged to the entourage of Venus, and since she too is a goddess of spring, they were associated with growth, flowering and fertility. Renaissance poets and mythographers were familiar with these concepts and continued the tradition of the Graces as the companions of Venus.

84 Feet of the Graces (detail of pl. 82)

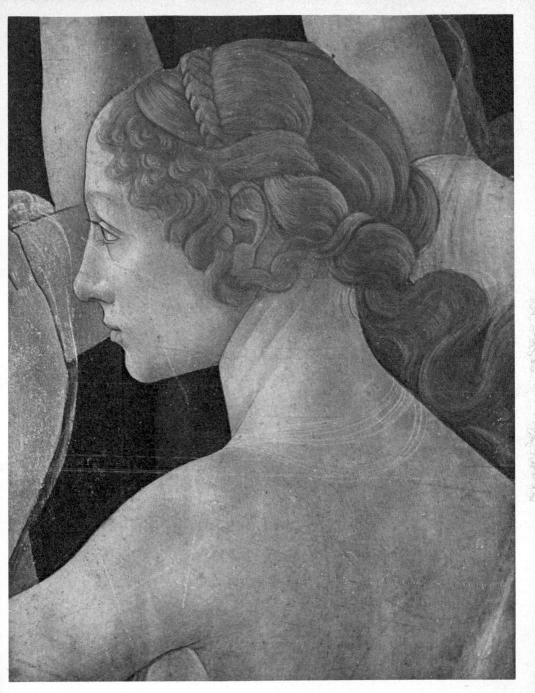

85 Head of one of the Graces (detail of pl. 82)

Equally old is Mercury's connection with the Graces, for he appears as their leader already in archaic Greek art and is still described in this role in the sixteenth century.

Although the beautiful figure of Spring in her rich dress decorated with blossoms has given her name to the painting, the key role is assigned to Venus, not only through her central position, but also by her gesture. While she is not looking at anyone in particular, her right hand, slightly raised with open palm, must signify some form of greeting. The identical gesture occurs on fifteenth-century Florentine Annunciations where Mary greets Gabriel in this way. It is unlikely that Venus is welcoming her companions because not one of them is even looking in her direction. We must therefore conclude that she is welcoming the beholder to her realm of spring.

So one thing can be said of this picture without fear of contradiction: the imagery is of Spring, which begins when Zephyr transforms Chloris into Flora and thereby brings forth the first flowers. The dance of the Graces is in celebration of the season. Venus and Cupid serve to remind us that love, too, is part of the Spring. Mercury is the only figure that does not have a specific association with Spring as a classical god, but as an astrological deity he rules over May as Venus rules over April, the two months in which the Floralia were celebrated. Astrology enjoyed a great vogue in the late Middle Ages and Renaissance, so that such a suggestion for Mercury's inclusion could be valid, but no entirely satisfactory explanation for his pose or action has yet been found.

Different interpretations may be given of the *Primavera*, and in the case of a Renaissance painting it is quite possible that it has more than one layer of meaning. Neo-Platonism was fashionable in the Medici circle, and Ficino was personally known to Lorenzo di Pierfrancesco, to whom he wrote a long letter about the time the *Primavera* was painted. In it he expounded for the benefit of the young man the value of *humanitas*, that is, the sum of all the qualities most esteemed in an educated man, and he personified this concept through Venus,

each part of her body standing for some virtue after which Lorenzo ought to strive.

Nobody ever claimed that the *Primavera* is a painted philosophy lecture, but it is possible to consider Botticelli's painting as somehow connected with Ficino's ideas. The central figure might be *humanitas*, but we should not overstress this possibility. There was constant debate about Plato, and philosophy and literature were much influenced by it. Whether the visual arts fell under the spell of Neo-Platonism is another matter and we are now realizing that its alleged ubiquitous impact has been exaggerated. In the case of Botticelli's painting we might use the old legal phrase, 'not proven'.

At a time when so much of the art historian's energy is spent on iconographic exercises and the ferreting out of esoteric sources, it may sound simplistic to suggest the Vasari was right and that a painting called 'Spring' less than a hundred years after it was created may be nothing more than its name tells: a series of delicate poetic images, all associated with that season and all having their sources in the mainstream of the classical tradition. It has been pointed out more than once that the same imagery occurs in the poetry of Poliziano. He is the most likely person to have introduced the painter to the symbolism needed to evoke the Spring.

Lorenzo di Pierfrancesco de' Medici must have had a taste for pictures using mythological figures in allegories of various kinds. The allegory was a legitimate vehicle for the revival of classical deities because they appear as harmless personifications or symbols rather than dangerous pagan gods. In the *Primavera* they personify various aspects pertaining to spring, so that such an allegory might be called cosmological. Perhaps even more popular were moral allegories in which personages from classical legend – Hercules, Pallas Athena, Apollo and so forth – represent moral forces (or their opposite). Botticelli's *Pallas and* 86 *the Centaur* appears to be an allegory of this sort.

Almost certainly this picture was painted for Lorenzo di Pierfrancesco for, according to an inventory of 1516, it was

hanging in his town house in Florence. Although the painting is now much restored, Botticelli's style is unmistakable. A comparison between the head of the centaur and that of Moses from one of the Sistine frescoes shows the same rugged features in both. It is therefore likely that the *Pallas and the Centaur* was painted in the early 1480s soon after the painter's return from Rome.

Pallas is dressed in a flowing gown adorned with interlaced diamond rings, a Medici device first used by Cosimo il Vecchio. Her shield, slung over her left shoulder, is on her back, and she holds a halberd instead of the more usual lance. Olive branches are entwined across her bosom and down her arms. Turning towards a centaur on the left, she grasps his forelock. Her smooth and serene features are the same as those found on many of Botticelli's portrayals of the Virgin or female saints –

38 compare, for example, the head of St Catherine from the *S. Barnaba Altarpiece* – while the centaur, his face distorted as if in pain or fear, cringes at her approach. Again, there is no classical prototype for the Pallas, but the centaur is a beast out of classical myth which could be found on many Roman sarcophagi. The search for a definite model is a futile one, for not only did other Florentine artists paint or carve centaurs, but the figure was well known before artists turned to classical models at all because it is used in the representation of the constellation and astrological figure of Sagittarius. In short, *Pallas and the Centaur*, like the *Primavera*, depicts figures from classical mythology without turning to classical art for models.

Since there is no Greek or Roman legend telling of an actual encounter of Pallas Athena with such a half-human half-horse creature, Botticelli's adviser must have suggested this composition because of the meaning attached to the two characters. Pallas, the goddess of wisdom, has been through the ages a personification of intellect and man's rational faculties. The centaur, on the other hand, a composite of man and beast, often symbolized the baser, sensual passions. The painting is thus in all probability a moral allegory celebrating the superiority

130

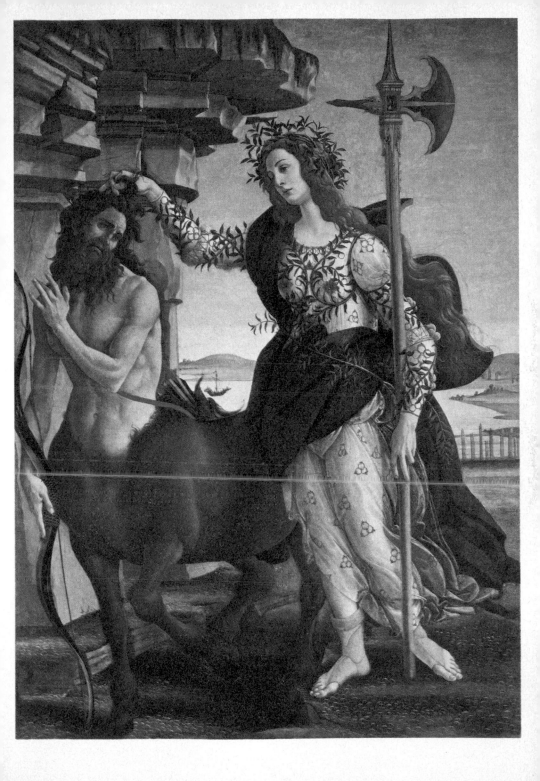

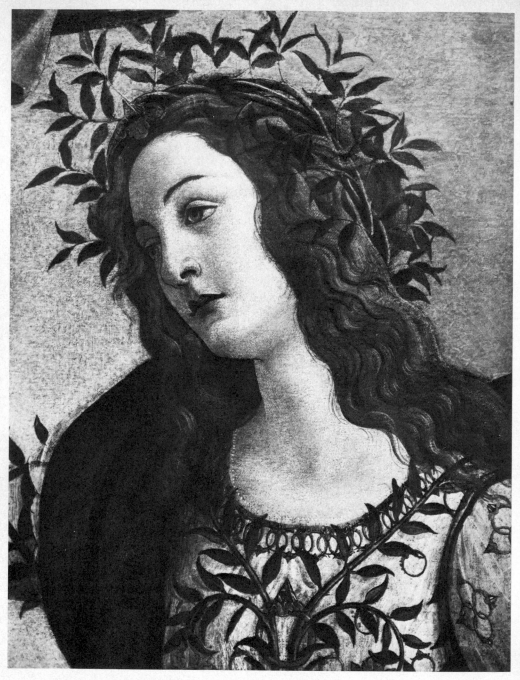

87 Head of Pallas (detail of pl. 86)

of rational thought over sensuality. The Medici device on the dress of Pallas makes the general principle into a personal compliment for the patron. Such an interpretation would be in accordance with Neo-Platonic maxims, and – remembering Pierfrancesco's intellectual background – is likely to have been intended when the picture was commissioned.

Still, such a straightforward interpretation has proved too much for some art historians who have tried to read a good deal more into this picture. In particular attempts have been made to find in this sensitive and poetic picture a piece of crude political propaganda, assuming at the same time that it was painted for or in honour of Lorenzo il Magnifico despite the fact that the rings were a device used by other branches of the family. Pallas is transformed to represent Lorenzo, the centaur hostile Naples, the ship in the background the means of transport between the two towns. Lorenzo's greatest diplomatic triumph had been the negotiation of a peace with Naples in 1480, but fortunately for us Renaissance imagery never worked on this kind of level – quite apart from the historical fact that mythology and ancient history served the purposes of political cartooning only at a later date.

The most famous of all of Botticelli's pictures is surely the *Birth of Venus*, a painting of magnificent elegance and great delicacy. Venus, standing completely nude on a sea-shell, is blown to the shore by the intertwined winds on the left. Roses rain down as an attendant of the goddess runs forward to greet her with a flower-embroidered cloak which billows out from the breath of the winds. Vasari also saw this poetic painting hung in Castello and it is therefore assumed that it too was commissioned by Lorenzo di Pierfrancesco although it is not mentioned in any early inventories. But although Vasari mentioned both the *Primavera* and the *Birth of Venus* in the same sentence there is no reason to assume that one is pendant to the other. Not only was the *Birth of Venus* painted some years after the *Primavera*, but it is on canvas, not panel, and it is slightly smaller in size, while the figures are more monumental.

Botticelli's mastery over form and colour was perhaps at its
88 peak when he created the *Birth of Venus*. The figure of Venus
utilizes a pose well known from classical antiquity but is
certainly anything but a document of classical revival. The
steeply sloping shoulders, the elongated body, the circular
breasts all bespeak Botticelli's preference for International
Gothic rather than classical proportions. To him beauty was a
matter of infinite grace and sinuous elegance. He preferred to
suggest Venus through a sensuous flow of line instead of by
bodily presence.

This love of line is amplified in the other figures. The two
winds, moving even more powerfully than Gabriel in the San
29 Martino *Annunciation*, are wound around each other and their
draperies twist about their limbs. The flying cloak and draperies
of the attendant do not follow any rational pattern but rise and
90 fall to fit the rhythm of the scene. The dignified Venus contrasts
with the agitated movement to her right and left, but her hair
belies the serenity of her face. It flies out in response to the winds
with each lock curving to compliment the others.

In spite of the more accurate 'classicizing' in the pose of
Venus, Botticelli has not forgotten the two-dimensional world
of tapestries. What little space exists is created by the giant shell
on which Venus stands, as it is the only thing which projects
into the depth. All the players in this scene are set forward on a
very narrow stage. Behind them the waves of the sea are
decorative patterns, the sky is a flat blue, and the suggested
landscape is out of scale to the figures. That this is not intended
to be a realistic representation is made perfectly clear by the
shading on the trees which is done with gold lines. It is precisely
this sort of summary treatment of the background that caused
Leonardo da Vinci to accuse Botticelli of throwing a sponge at a
picture in order to create a landscape.

According to ancient legend, Venus was born from the foam
of the sea. This myth was retold by Angelo Poliziano in his
poem *La Giostra* which celebrates the famous joust of Giuliano
de' Medici in 1475. In it Poliziano describes the palace of Venus

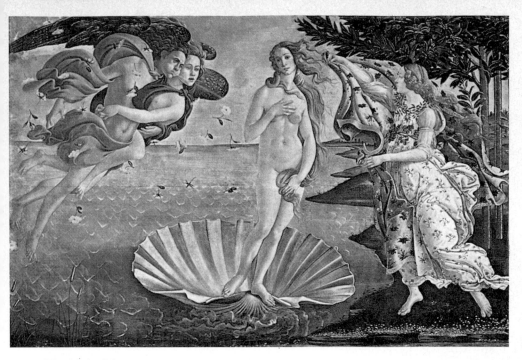

88 *The Birth of Venus*

and its decorations, among them a relief depicting the birth of the goddess from the sea and her arrival on the shore. It is of little consequence that there are differences between the details of this account and Botticelli's painting, for the core of the story remains untouched. Botticelli's commission must have been for a *Birth of Venus*, and someone, possibly Poliziano, must have given him an account of the incident. But no discerning patron would have asked a painter of Botticelli's rank to follow slavishly an incidental passage in a long poem. It is much more likely that he expected the painter to invent a composition capable of holding a place on its own terms by the side of a poetic description.

Once again Botticelli's picture can be interpreted on more than one level. The *Birth of Venus* is perfectly comprehensible as a straightforward narrative of classical myth. But there may

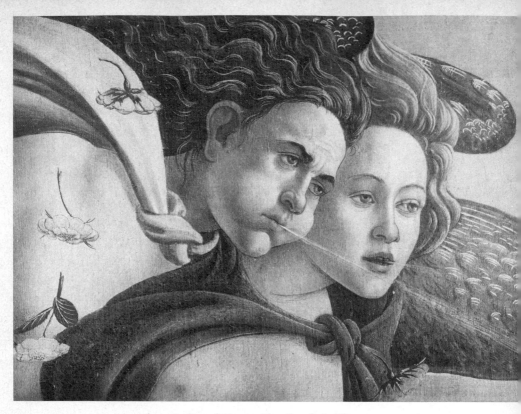

89, 90 The winds and Venus (details of pl. 88)

have been more than an interest in the ancients in the commissioning of such a picture in the 1480s. The *Birth of Venus* may also be seen as an expression of Neo-Platonic convictions as long as this refined painting is not forced to become a mere illustration of some definite text. It has already been said that Marsilio Ficino was a friend and mentor of Lorenzo di Pierfrancesco and he expounded philosophy to the young man at quite inordinate length. To him, and to anyone familiar with the works of Plato, Venus could personify beauty, and beauty was identical with truth. Looked at in this way, the *Birth of Venus* could become a philosophical and moral allegory, but the literal and allegorical meaning are not mutually exclusive.

136

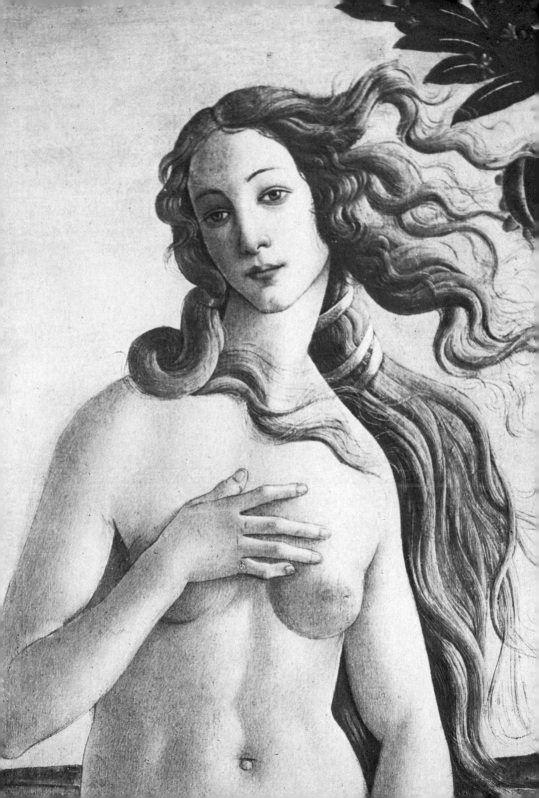

Botticelli's *Mars and Venus* is, in all probability, the latest of his surviving mythologies, for the style of the painting clearly belongs to the latter half of the 1480s. As in the case of the *Birth of Venus*, the subject is superficially quite simple and straightforward. The god of war, stretched out nude on the ground, has fallen asleep, while baby satyrs play with his armour. Venus, fully clothed and awake, reclines opposite him.

The love of Mars and Venus had been a popular subject since the days of Homer and was treated frequently in art and literature. An erotic topic of this kind would seem suitable for a marriage chest but the size of Botticelli's panel excludes such a use. It is perhaps more likely to have been a headboard for a bed or a decorative addition to some large piece of furniture, but it may still have been painted for a wedding. From the tree-trunk on which Mars sleeps wasps are swarming. They appear in

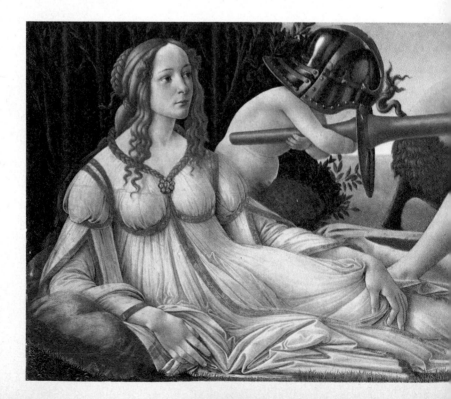

exactly the spot where a coat of arms on a *cassone* picture was normally placed. It has been suggested that these wasps – *vespe* in Italian – are a punning allusion to the name of the Vespucci in whose coat of arms they appear. For lack of further evidence we cannot say for which member of this large family the picture might have been painted nor can we name the occasion.

Although *Mars and Venus* were traditional lovers there is no classical or Renaissance text describing them as Botticelli depicts them in this painting. It seems therefore that once again, as was the case with the *Primavera*, classical myth has been used in a personal way. For it is indeed an odd love story which shows us the man sunk in torpor while the woman is wakeful *92,* and alert. Not surprisingly, among the comments on *Mars and* *93* *Venus*, lewd observations on this aspect can be found.

91 *Mars and Venus*

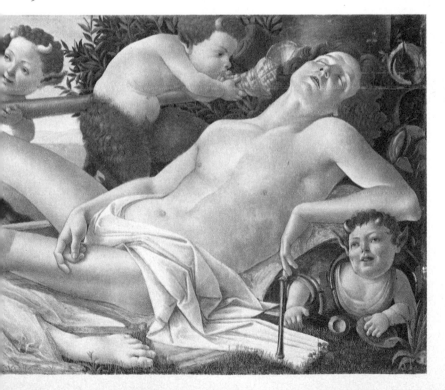

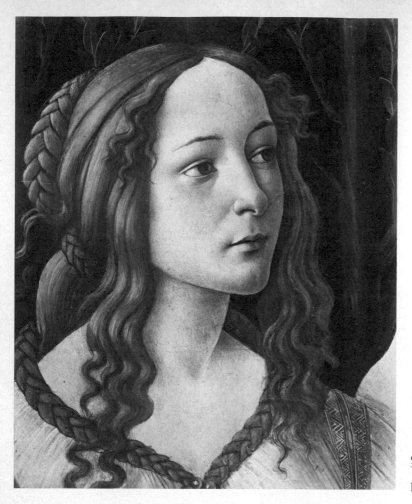

92 Head of
Venus (detail of
pl. 91)

Perhaps astrology, so popular at this time, can provide a possible explanation. Since Mars and Venus are both planet deities their characters are reflected in their influence. In one of Ficino's commentaries on Plato he explained that Mars is outstanding among planets because of his strength, and that therefore he can make men stronger. Yet his influence is not always beneficial as the borderline between strength and brute force is a slim one. Venus, on the other hand, watches him, curbs his bad influence, and can even overcome him. In

astrological terms the painting might therefore speak of the power of love over strength.

Mars and Venus is again a picture of classical personages painted without classical models: in spite of various suggestions that have been put forward neither deity is derived directly from reclining figures on Roman sarcophagi. If Botticelli was looking for models of this pose he could find them more easily – and better ones – in the top and bottom strips of the frame of Ghiberti's second Baptistery doors. However, the painting does contain an amusing echo of classical literature, albeit a minor one. Lucian had described a famous Greek painting of the wedding of Alexander the Great with the Persian princess Roxanne, an account well known in the Renaissance.

93 Head of Mars (detail of pl. 91)

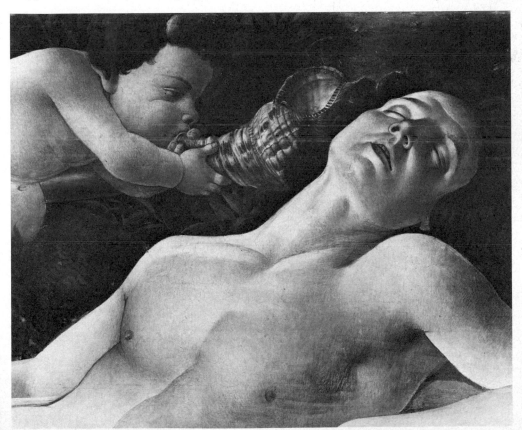

94 Illustration to Dante's *Inferno*, Canto XVIII

Apart from the main scene of the wedding Lucian had also given a circumstantial account of the by-play, in particular of the amoretti who are playing with Alexander's armour while the wedding is in progress. This description is too close to the portrayal of the playing little satyrs on Botticelli's picture to be fortuitous. These details must come from Lucian. Such a 'reconstruction' of an ancient painting from a verbal account is not unusual in the Renaissance – Sodoma's *Alexander and Roxanne* is perhaps the best-known specimen – and Botticelli's *Calumny of Apelles*, also taken from Lucian, is an outstanding example of this genre.

Vasari knew the picture and says that it was painted for Botticelli's friend Antonio Segni. The few known facts about Segni's life make it likely that Botticelli worked on it just before the middle of the 1490s, a date confirmed by the style. The subject is an odd one. It is an elaborate allegory originally painted by the most celebrated Greek artist Apelles and described in great detail by Lucian. His account was taken up by Leonbattista Alberti, who embodied it into his treatise *On Painting* (1435), recommending the subject to painters as a particularly suitable 'invention'. Briefly the story is this: Apelles had been accused by a rival of plotting against his patron, King

95 Satyr (detail of pl. 91)

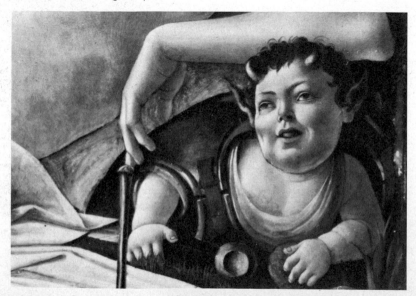

Ptolemy Philopater. After his vindication he painted a picture showing a judge counselled by Ignorance and Suspicion while Calumny, lead by Envy and attended by Treachery and Deceit, drags in the innocent victim. Remorse stands by and turns to the figure of Truth.

Lucian was widely read during the fifteenth century and his works were available in Latin translations. Alberti followed his account closely, differing only over inessential details. Still, just these indicate that Antonio Segni, or whoever acted as Botticelli's learned adviser must have shown both texts to the painter.

Such an esoteric topic was surely not chosen for its own sake, but because Alberti had recommended painters to emulate classical precedent. However, that cannot be the only reason, particularly for a painter like Botticelli who was not a 'revivalist'. Both Lucian and Alberti had described in some detail the character and expression of the figures involved, the latter arguing that the story was a good one in itself, but it would be even more appealing if Lucian's words were translated into paint. This was a challenge which must have appealed to Botticelli.

To begin with, in characterizing the various personifications, Botticelli has expanded on the mere hints given in his texts. The judge is given long ears (mentioned by Alberti but not by Lucian) because they are an ingenious satirical visual allusion to the failings of a man willing to listen to anything whispered into his ear. For the representation of Calumny, described in both sources as a beautiful woman, Botticelli has taken the same facial type he used habitually when painting Venus or the Virgin. While neither Lucian nor Alberti had said anything about Remorse beyond mentioning her black dress, Botticelli has made her into a bent old woman wearing a kind of nun's habit, suggesting a penitent. The most significant rendering, however, is that of Truth. She stands on the extreme left, apart from the others, points to heaven, and is nude. Obviously in inventing this image Botticelli remembered the old adage, of classical origin, that Truth is naked. But in depicting her he

98

97

quoted directly the central figure from the *Birth of Venus*, and, remembering that to the Neo-Platonist beauty was truth, one wonders whether this model was not chosen with the intention of conveying a specific meaning.

The composition of the picture is strongly dramatic. Truth acts like a steadying pillar on the left but the other figures surge vehemently to the right and come to an abrupt halt by the judge's throne, like waves breaking on a rock. Although the courtroom is a spacious hall, the figures bunch closely together, their movements fierce and sharp. The colours are strong, the drawing is brittle. These are the characteristics of Botticelli's late style, already observed in his religious painting of that period.

Neither Lucian nor Alberti had described the setting of Apelles' *Calumny*, so that Botticelli had to invent his own. He has constructed an ornate gallery, the walls of which are covered with statues in niches and with reliefs filling even the coffered vaults of the arcade at the rear. Though such an interior must have been suggested by descriptions and remains of Roman architecture, the statuary in particular does not resemble classical art in the least. The David in the niche on the left seems inspired by Donatello's early marble of the same subject and the St George in the niche on the right has some affinity with Donatello's *St George* from a niche on Or San Michele. But these similarities are more in the poses than in treatment. The absence of a classical style is also noticeable in the reliefs, even where their subject-matter is taken from Greek myth. Botticelli's independence may be seen, for example, on the Apollo and Daphne plaque (by Truth's waist) where the nymph, contrary to all precedent, changes into a laurel from the head downward.

The subjects of these decorations have been taken at random, it seems, from biblical and secular sources. The Judith story is depicted behind the judge, David and St George are prominently displayed in niches and exploits of Hercules appear on reliefs. Although these are favourite Florentine heroes, no special significance can attach to them in this case, because there

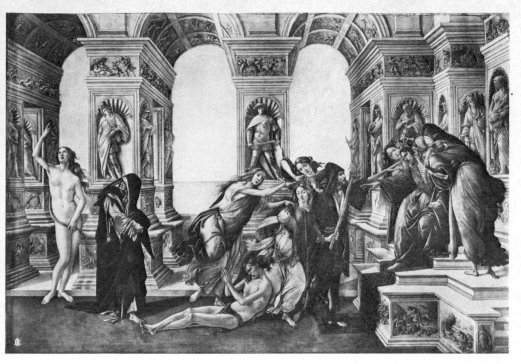

96 *Calumny of Apelles*

are also putti riding on the backs of centaurs, a satyr family and so forth. No complex iconographic programme is hidden in these reliefs with their many subjects, but through them the painter could suggest antiquity and in doing so he could demonstrate his skill. The statues simulate marble and the reliefs suggest gilded bronze. The ornateness of Botticelli's *Calumny of Apelles* shows that patrons not only wanted certain subjects but that they set great store by the artistry of the men they employed.

Just as Botticelli's mythological allegories do not copy classical models, even in details, so his reconstruction of one of the most famous paintings of antiquity is not the work of a learned antiquarian. In fact, Botticelli's *Calumny* would not have been understood by Apelles and his contemporaries because the painting's pictorial idiom is that of its own century. Still, Segni, the patron, must have been a man familiar with

97, 98 OVERLEAF Truth and Remorse, and the judge (details of pl. 96)

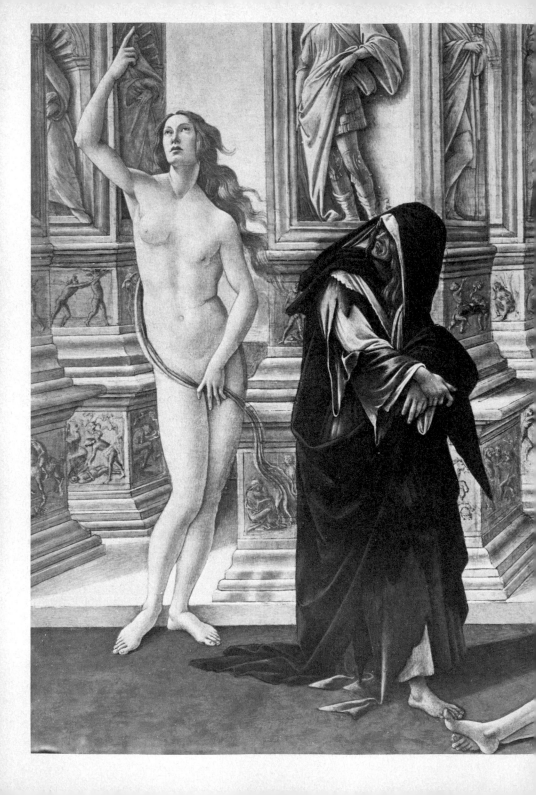

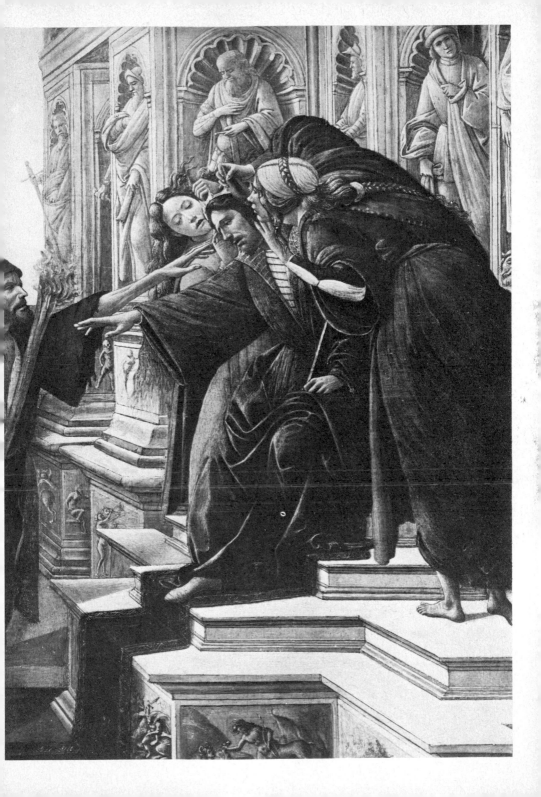

ancient art and literature and, at the same time, an admirer of contemporary painting. By the same token, the mythologies were produced for patrons who not only liked classical legends but could also find in them a moral applicable to their own lives. Today it is no longer necessary to prove that there is nothing 'pagan' or even anti-Christian in any of these paintings. Botticelli never abandoned religious paintings for secular subjects. *Pallas and the Centaur* is contemporary with the *S. Barnaba Altarpiece* and the *Calumny* must have been painted about the time of the Munich *Lamentation*. There is no contradiction here, for the religious and secular spheres co-existed. A deep interest in classical art, literature and philosophy continued as a cultural force even in Savonarola's Florence.

In 1873 three frescoes were discovered under whitewash in a villa just outside Florence which at one time had probably belonged to a member of the Tornabuoni family. Through centuries of neglect these frescoes had suffered much damage; but some of their dilapidation was also due to the fact that they had not been painted in a pure fresco technique (that is, painted on the plaster while it was still wet), but rather finished *a secco* after the plaster had dried. Of one only fragments remained, but the other two, depicting respectively a young man and a young woman with allegorical female figures, were sufficiently well preserved to be sold to the Louvre. Unfortunately further damage was incurred in the course of the removal to Paris where their poor condition has been masked by hanging in an ill-lit corridor.

These paintings are neither documented nor mentioned in any of our early sources, but there can be no doubt that they are *100* from the hand of Botticelli. One of them shows a young man approaching from the left and being led by a young woman to a group of women seated on the right. These figures can only be the Seven Liberal Arts, for several of them carry their *101* conventional attributes. The girl with the scorpion must be Logic, the one holding a table with mathematical figures is identifiable as Geometry and only Music would be shown with

150

a portable organ. The identity of the lady guiding the young man to the Arts has not been established. On the other fresco a 99 young woman holding a scarf or veil is standing on the right and is being approached by four females coming from the left. These lack all attributes and therefore cannot be identified. It has been suggested that they are Venus and the Graces, but this cannot be proved. Still, the idea that the Arts make suitable companions for a man and the Graces for a woman would be in keeping with the social conventions of the fifteenth century.

When the frescoes were found they still had the remains of painted shields with family arms on each of them, but unfortunately these were destroyed in the removal. But one vital piece of information remained. On the young man's side appear the arms of the Albizzi, so we may conclude that the frescoes were painted on the occasion of the wedding of some member of this large and important family. Originally it was thought that the young couple were Giovanna degli Albizzi and Lorenzo Tornabuoni who married in 1486. But this has been disproved because the features of the young lady on Botticelli's fresco are not those of Giovanna which we know from a medal struck on the occasion of her marriage. However, some time before 1485 Matteo degli Albizzi married Nanna di Tornabuoni, and they must be the personages in whose honour these wall-paintings were commissioned from Botticelli. The date is corroborated by the style which is still very close to that of the Sistina frescoes. In fact, the four girls on Nanna's fresco look like sisters of the daughters of Jethro. 32

Even in their ruined state these frescoes still preserve something of Botticelli's charm and elegance. Matteo and Nanna move with grace and dignity as befits the occasion. An attempt has clearly been made to differentiate between the features and expressions of the Arts, yet their faces remain ingenious variations on Botticelli's basic type of a female head. It is again a mark of the span of Botticelli's imagination and powers as a painter that he managed to imbue so unpromising a subject with so much life.

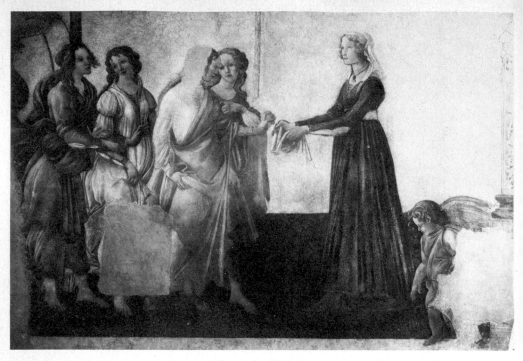

99, 100, 101 Frescoes from the Villa Lemmi, near Florence. Above: possibly Venus and the Graces; below: a young man introduced to the Seven Liberal Arts; opposite: detail showing Logic

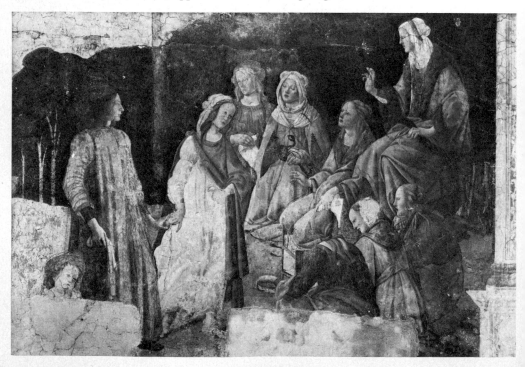

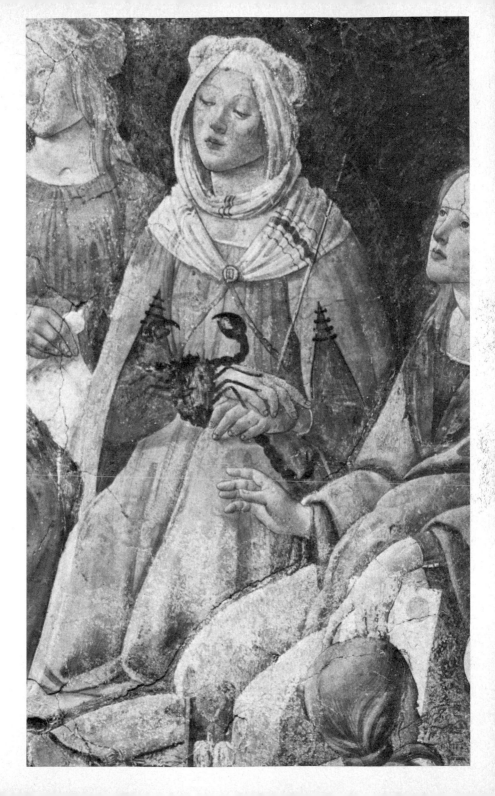

102 *Portrait of a Young Man*

Portraits

THE CONCEPT OF THE PORTRAIT changed greatly with the advent of the Renaissance. During the Middle Ages, portraits, by and large, had been official or semi-official representations of the man depicted, rather than individualized representations of human beings. Adding to the restricted nature of such 'portraits' was the concept that only rulers and high church dignitaries, by virtue of their office, were worthy of such honour. But, as Jacob Burckhardt argued in a celebrated chapter in his *Civilization of the Renaissance*, the desire for personal fame and commemoration became an important driving force during the Renaissance. In making such a claim Burckhardt could refer back to the many utterances of the period which lay stress on the perpetuation of the individual and the memory of his works.

Furthermore, a change in social structure greatly helped to develop the portrait. With the growing wealth and power of the merchant class and the rise of humanism, it became possible to think that people and not positions should be immortalized for future generations. One of the first manifestations of this desire for personal commemoration is the appearance of donor portraits on the sides of religious paintings. Once this had become acceptable it was a short step to the intermingling of contemporary and historical personages in narrative religious paintings. But the real innovation came with the rapid development of the individual portrait during the fifteenth century, both in sculpture and in painting. The great popularity enjoyed by this genre is evident from the large number of paintings of varying quality which have come down to us.

It must be said at once that there is hardly another type of painting in which it is more difficult to attribute works to

particular artists. Since the vast majority of these paintings are neither signed nor documented, virtually every painter since Masaccio has been credited with a number of them. In addition, there is in most cases no evidence as to who is portrayed and so the attachment of such names as 'Giuliano de' Medici' or that of some famous contemporary beauty is, for the most part, wishful thinking on the part of modern historians.

As a portrait-painter Botticelli must have enjoyed a considerable reputation in Florence or he would not have been asked in 1478 to paint the life-sized effigies of the executed or imprisoned Pazzi conspirators on the wall of the Bargello. Although these no longer exist, Botticelli's skill as a portrait-painter can still be gauged from a number of paintings which are certainly by his hand.

Masaccio had been the first to include the portraits of contemporaries in biblical narratives in the frescoes of the Brancacci Chapel. The selection of such individuals was not arbitrary; they were always people closely connected with the donor and his family. That they are not characters in the story but real people who witness the holy incident is made perfectly clear by the fact that they wear contemporary dress rather than the standard historical costume. By the latter part of the fifteenth century not only frescoes but also panel pictures and altarpieces contained such figures, and the habit spread from Florence to other regions of Italy.

As far as we can judge today, the earliest extant example of a painting by Botticelli embodying such portraits is the *Adoration of the Magi* now in the Uffizi. It will be remembered that Vasari claimed that three generations of the Medici family appear in the guise of the three Kings and it should be reiterated that when this picture was painted in the late 1470s all three were dead. Nevertheless Botticelli took great care to create true renderings of the persons portrayed, using as models contemporary or near-contemporary portraits. The sensitivity and liveliness of their portrayal is remarkable, particularly as Botticelli has also shown the devotion of the Magi through gestures and

26
103,
104

103 Supposed portrait of Cosimo il Vecchio in the *Adoration of the Magi* (detail of pl. 26)

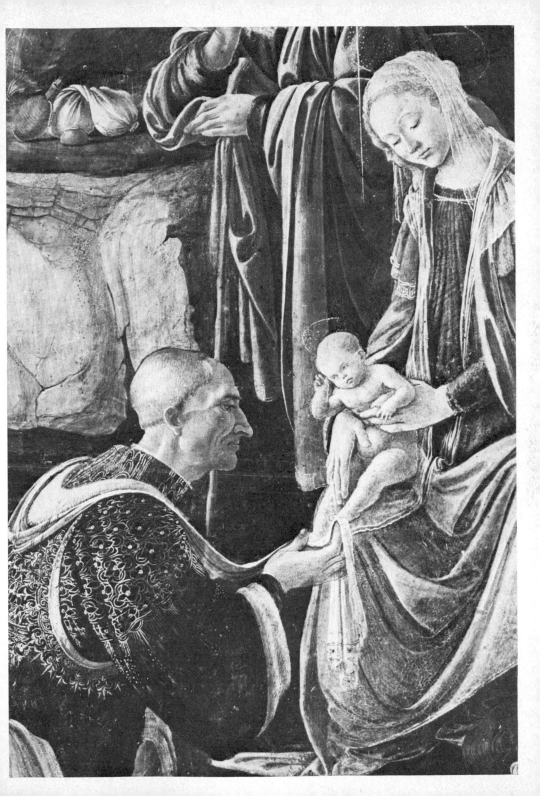

104 Supposed portraits of Piero and Giuliano de' Medici in the *Adoration of the Magi* (detail of pl. 26)

expressions. It is almost certain that many of the onlookers are portraits of people who were alive when the picture was painted. Various attempts have been made to identify most of the figures but there seems only one incontestable identification. The sombre-looking dark-haired man in black standing behind the kneeling king in white can only be Lorenzo il Magnifico, as can be seen by a comparison with other contemporary portraits. The fact that he is placed behind his murdered brother, wearing the colour of mourning, confirms such an identification.

105

 The decoration of the Sistine Chapel demanded from Botticelli and his colleagues two different kinds of portraiture. Not only were the scenes from the lives of Moses and Christ

158

105 Another detail of pl. 26 including the supposed portrait of Lorenzo (left)

106, 107 The Pazzi medal, 1478, with portraits of Lorenzo and Giuliano

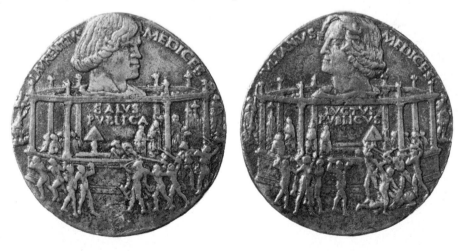

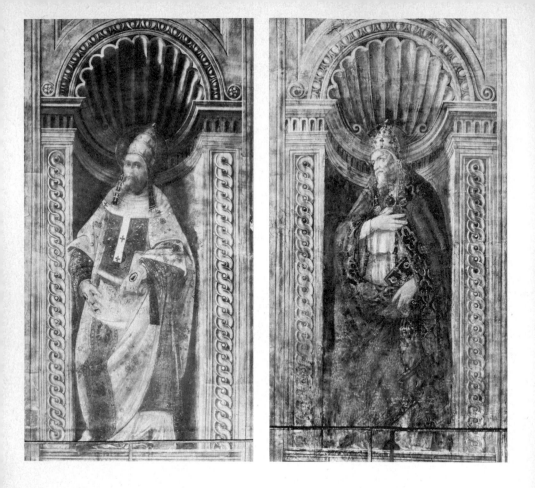

108,
109 populated with contemporary onlookers but idealized portraits
of the first twenty-eight popes had to be created for their
depiction in the clerestory. The basic form for each figure was
the same: a halo, some attribute to identify the individual, and
the papal tiara and full pontificals, though these were unknown
to the early Church. Thus these figures revert to medieval usage
in their conception as splendid representatives of the Roman
Church and its claims, but they are not faithful renderings of
actual historical figures. Botticelli has tried to distinguish his
figures not only by their attributes but also by individualizing
their features. Some are reminiscent of his saints, others of the

108, 109 Two figures
of early popes (St Soter
and St Sixtus II) from
the clerestory of the
Sistine Chapel, Rome

110 Portrait detail
from the *Temptation of
Christ* (pl. 34). Sistine
Chapel, Rome

biblical characters in the frescoes below. It should be noted that
while the master himself would certainly have designed those
papal figures which fell to his share, it is unlikely that they were
executed in their entirety by his hand.

In the narrative frescoes of the Sistine Chapel the biblical
characters are interspersed with Botticelli's contemporaries in
Quattrocento dress or, in the case of clerics, in robes befitting
their office, as for example, the ecclesiastic in the *Temptation of* 110
Christ fresco. In spite of these details of costume it is not possible
to identify him although it has been suggested that he may be
one of the Pope's nephews. It is equally impossible to say who

161

112 the nobleman in the foreground of the illustration opposite might be. His strong features are beautifully portrayed in what is a highly individualized portrait. The fact that we cannot identify this and other figures should not detract from our appreciation of Botticelli's powers as a portraitist.

111 To give yet another example: in sharp contrast to the biblical figures involved in the action are the two bystanders on the left side of the *Punishment of Corah* fresco. Their portrait character is especially obvious because neither so much as glances at the horrifying end of Corah and his followers and they seem isolated in both time and space from the incident. Examples of this kind can be found not only in all Botticelli's frescoes, but also in those of his colleagues. Still, it is difficult to say whether such an inclusion of contemporary portraits was nothing but a way of flattering members of the court of Sixtus IV or whether it was meant to signify the timeless importance of the biblical events depicted.

111 Two bystanders from the *Punishment of Corah* (pl. 31). Sistine Chapel, Rome

112 Detail of figures on the right edge of the *Temptation of Christ* (pl. 34). Sistine Chapel, Rome

Most of the 'identifications' of the many portraits in the Sistina frescoes are spurious because the identification of portraits 'hidden' in Renaissance paintings has become a parlour game among scholars. Occasionally a medal, a miniature, or an authenticated portrait does allow us to identify a face, but more often than not such conveniences do not exist. In such cases, rather than admit that the problem is insoluble, critics have put forward suggestions which are not only unprovable but often completely impossible. Perhaps one of the most outrageous examples of this kind is the nineteenth-century 'discovery' of Lorenzo il Magnifico in the guise of the youngest of the three Kings in Gozzoli's fresco in the chapel of the family

163

palace, an 'identification' which has gone into most guidebooks unchallenged. The fact that this figure is a handsome fair-haired youth with a straight nose, while Lorenzo was dark and snub-nosed, has not discouraged this legend.

Another myth which has persisted in spite of all evidence to the contrary is the tale of Giuliano de' Medici and his paramour, La Bella Simonetta. This story was first popularized in the nineteenth century by Ruskin in a highly suggestive form. He maintained that Simonetta, after Giuliano's death in 1478, allowed herself to be painted in the nude by Botticelli and thereby engendered a secret lust in the painter's heart which manifested itself in the *Birth of Venus*. Ruskin either did not know, or chose to ignore, the fact that Simonetta had died of tuberculosis two years before Giuliano.

The whole legend is based largely on a Romantic mis-interpretation of Poliziano's *La Giostra*, the poem which we have already noticed in connection with the *Birth of Venus*. In this unfinished work (which is dedicated to Lorenzo il Magnifico) Simonetta, the young *La Giostra*, Marco Vespucci, is briefly mentioned twice in connection with Giuliano but this association, together with the numerous elegies composed on her death, has caused a fog of myth to envelop the protagonists. In fact, there is no evidence that Simonetta was Giuliano's mistress. Adding to the confusion is a remark by Vasari that Botticelli painted 'the beloved of Giuliano', but without mentioning her name.

All this had led to the attribution of many female portraits of both Renaissance and nineteenth-century origin to Botticelli and to their being dubbed, 'La Bella Simonetta'. These labels have been discredited by recent scholarship, but the legend refuses to die. Not only has it been seriously suggested that *Mars and Venus*, the *Primavera*, and *Pallas and the Centaur* are allegorical renderings of this 'love story' but even such 115 different-looking women as a profile in Berlin attributed to 113 Botticelli and another in Florence by Botticelli have been labelled 'Simonetta Vespucci' at one time.

164

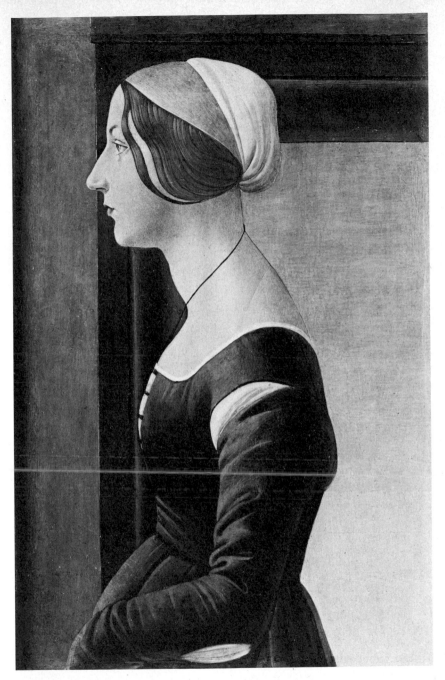

113 So-called 'Simonetta'

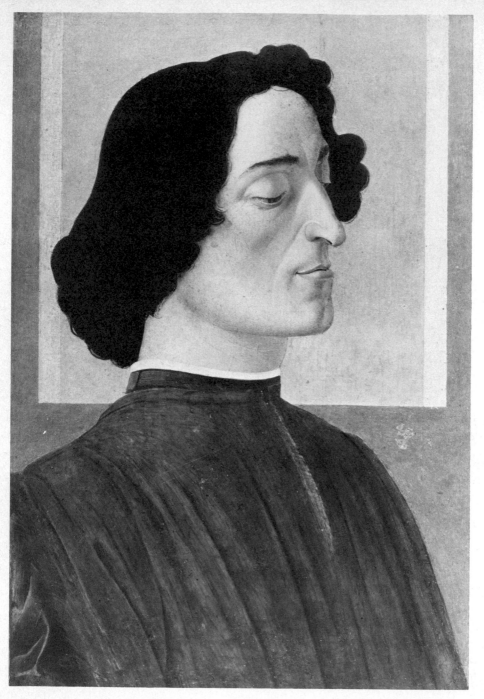

114 So-called 'Giuliano de' Medici'

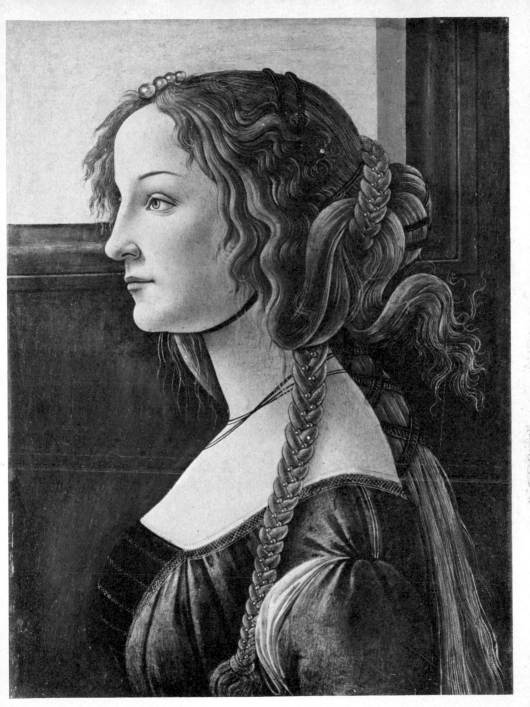

115 Workshop of Botticelli: so-called 'Simonetta'

There is as little reason for these identifications as there is for calling the latter portrait Fioretta Gorini, Giuliano's known mistress and the mother of Pope Clement VII. It would be better to leave these charming and finely painted ladies nameless and enjoy the pictures for their own sake.

115 The Berlin portrait, once believed to be by Botticelli, is now generally accepted as a workshop piece.

113 The fine portrait in the Pitti Palace is based on the traditional formula used in Florence of a profile placed against a simple background. But to give life to the composition Botticelli has placed the figure slightly off-centre and emphasized the outline of the face by contrasting it with the darker doorframe in the background. The loosened strand of hair heightens the effect of this being a portrait from life. The taut and simple outline, the delicacy of modelling, and the plain costume are matched by the subtlety of colouring, a combination of greys and browns against a pale blue ground. While Botticelli hardly gives us a psychological reading of his sitter, the picture certainly conveys something of a noble grace.

 Another portrait attributed to Botticelli which is, in all
114 probability, wrongly identified, is the so-called 'Giuliano de' Medici', a picture which exists today in no less than four versions, none of which seem to have been noted before the nineteenth century. The sitter is shown in two cases against a plain background, in one against an open window and once against an open door. The person portrayed bears little resemblance to Giuliano de' Medici as we know him from the Pazzi conspiracy medal or Botticelli's rendering of his features
104 on the Uffizi *Adoration of the Magi*. It is of course possible that some Botticelli portrait is behind all four versions, but we are not in a position to say who is represented, and it is not even certain that all four versions date back to the fifteenth century. But the naming and attribution of these works shows the persistence of the belief that Botticelli was the favourite artist of the Medici and the popularity that Giuliano still enjoys today.

168

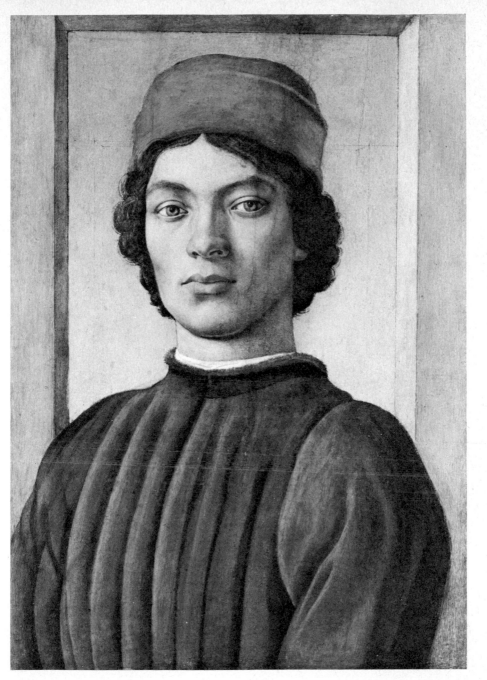

116 *Portrait of a Young Man*

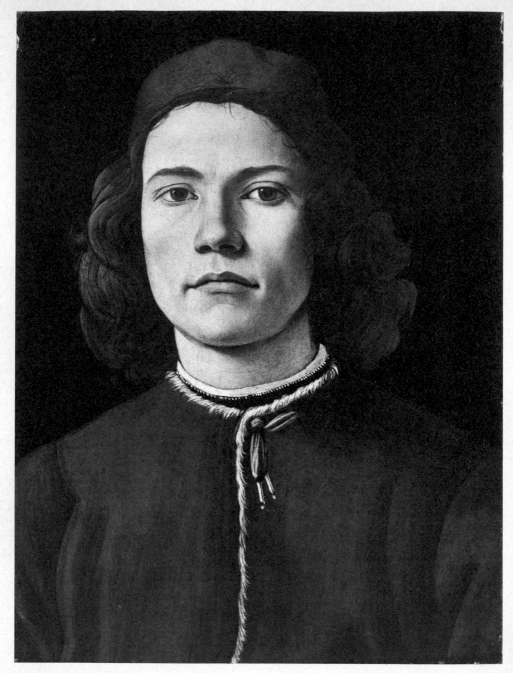

117 *Portrait of a Young Man*

Three very fine portraits of young men which are certainly by Botticelli have remained anonymous over the years in spite of much diligent research. The first of these uses the formula of a light background with the suggestion of a window in front of which the figure sits. But to prevent the image from being too static, Botticelli has placed his sitter in such a way that the body is slightly turned to the left while the face is full front. Botticelli has captured not only the magnificent head but also the superb carriage of the figure. This power contrasts sharply with the other two portraits, both of which are set against a plain dark ground and appear to be much more relaxed. Only the upper bust and head are visible, although one of the young men puts his hand to his breast and tilts his head slightly, giving a variation on the basic theme. The charm in these faces lies in the great delicacy of the handling rather than in any innovative design. The same format was also used by Leonardo for his early *Ginevra de' Benci* and it was only with his imaginative treatment of the *Mona Lisa* that the static posing of Quattrocento sitters was revolutionized.

116
117
102

Yet Botticelli did paint the most unusual of all Florentine fifteenth-century portraits. His *Young Man with a Medal* shows a conventional placement of the bust with the firmly modelled face turned slightly to the right and the eyes looking straight out. Behind is a very summarily treated landscape, perhaps partly the result of overpainting. But what is unique in the whole of Renaissance portraiture is that this young man holds a medal which, instead of being painted, is a gilded gesso cast inserted into the panel. There is obviously some special reason for this strange mixture of painting and relief, but since it has so far proved impossible to identify the young man, it cannot be determined. Nor does the medal offer any clues. It is a cast of the well-known medal of Cosimo il Vecchio struck after his death in 1464, but the features of the young man are certainly not those of any known member of Cosimo's family. It has been suggested that this is a portrait of the maker of the medal (whose name is uncertain) but it would be most unusual at this time for

119
118

an artist to portray himself in this manner, advertising his trade like a shop sign.

In the end the lack of identification perhaps does not matter. We can never know how faithfully Botticelli has portrayed his sitters. It seems therefore that any remarks made about the painter's psychological penetration or subtlety in rendering character spring more from the mind of the beholder than the overt intentions of the artist. Botticelli's portraits fascinate for their gracefulness and delicacy, but not for any revelations of the 'Renaissance mind'.

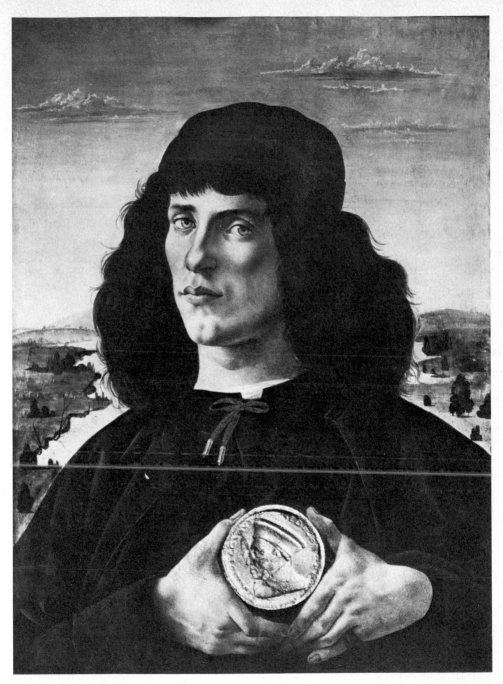

118, 119 *Young Man with a Medal*, and detail of the medal (left)

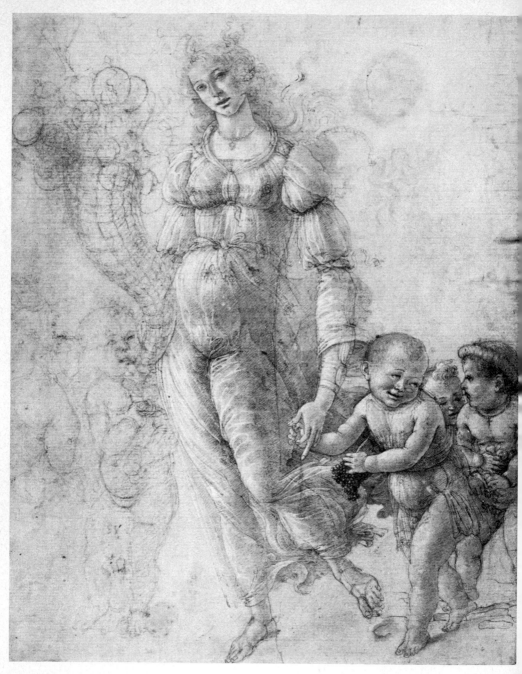

120 *Abundance*

Drawings

DRAWINGS IN THE FIFTEENTH CENTURY were not, as today, done for their own sake. Not only were paper and parchment expensive but the concept of a drawing as something on a level with a painting or an illumination had not yet evolved. By and large the bulk of Quattrocento work extant today is in the nature of studies – preliminary and advanced – for larger works. Artists used their sketchbooks to make notes of figures that interested them or that might be incorporated into a painting at a later date, but never with the ultimate aim of having such drawings displayed as finished artistic creations. The use of live models was still a novel practice in the Quattrocento and apprentices first copied from pattern-books provided by their master to improve their skill. It is therefore perhaps not surprising that only a handful of drawings attributed to Botticelli remain, for, as we have seen, his workshop produced many paintings which even in his own day passed for the master's hand and his pattern-sheets must have been well used by the time of his death. Furthermore, since Botticelli was out of fashion already during his final years, it is likely that, as paper was more precious than old drawings, what remained was used for other purposes. By the time Vasari began to collect drawings in the sixteenth century only very little can have survived of Sandro's work. It is interesting to note, however, that Vasari claimed to have some drawings by Botticelli, and there is some evidence that the *Abundance* in the British Museum *120* was one of these.

This allegorical female figure is surely one of the finest Quattrocento drawings. Holding a barely outlined cornucopia in her right arm she steps forward, accompanied by putti, her dress fluttering about her and her hair falling loosely around her

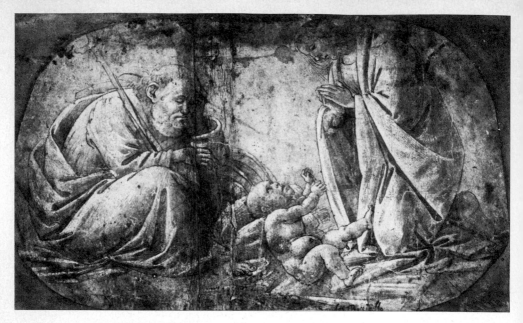

121 *Nativity Scene*

shoulders. The incomplete portion of the drawing is sketched in
black chalk, but the figure of Abundance herself is highly
finished in pen and wash with highlights in white. Although
there is no known painting by Botticelli which uses the figure
directly, it is a variation on a pose which Botticelli employed
83 again and again, from the Flora on the *Primavera* to Venus rising
90 from the sea. Perhaps the closest similarity is with Pallas from
· 86 *Pallas and the Centaur*. Not only are the dress and drapery almost
identical, but also the over-long left arm emphasizes the
relationship.

 Another drawing of Botticelli's has much the same
122 ambiguous relationship to his paintings. This, a *St John the
Baptist* in pen and wash, is obviously close to the representation
43 of the saint in the *Bardi Altarpiece*, though the figure is reversed.
But the fact that there is not a literal transfer of images should
not detract from the beauty of the drawing, particularly in the
fine rendering of the expressive head and hands.

176

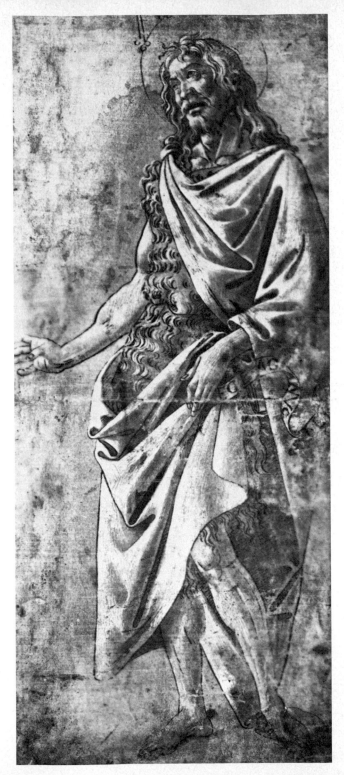

122 *St John the Baptist*

One drawing that does seem to be closely related to a
121 painting is a *Nativity Scene* which may contain one of
63 Botticelli's ideas for the central group of the Pierfrancesco
Nativity. Both the Child and St Joseph are more prominent in
this drawing than in the painting, but the basic poses have
already been worked out. The Child kicks His left leg into the
air and looks up at the Virgin who is kneeling in adoration. St
Joseph sits in thoughtful repose looking towards the Child, his
face fully visible. Everything is done through simple descriptive
contour. Such simplicity of technique and concentration on
essentials make this a very moving drawing.

One of our pre-Vasarian sources mentions that Botticelli
illustrated a manuscript of Dante's *Divina Commedia* for
Lorenzo di Pierfrancesco de' Medici. These drawings, although
much admired at the time, did not materially influence
later Dante illustrations. The codex must have vanished during
the first half of the sixteenth century, for although Vasari
mentions Botticelli's illustrations, he had obviously never seen
them. It was not until the nineteenth century that the drawings
resurfaced, when they were sold from a Scottish collection to
the Berlin Museum in 1884. A few years later eight further
leaves were discovered in the Vatican Library among the
treasures bought from Queen Christina of Sweden in 1690. As a
result of confusion during evacuation in the last war, the Berlin
drawings are today divided between the East and West Berlin
Museums.

This magnificent manuscript was obviously intended to be a
deluxe production. Printed books were sometimes looked upon
as cheap substitutes for hand-copied books, and there were even
fastidious collectors and connoisseurs who would not permit a
printed book in their libraries. Each leaf measures 32 by 37cm
and is of the finest goat-skin parchment. On the rough side, in a
beautiful late fifteenth-century hand, Dante's text is set out in
four columns; on the smooth side are the full-page illustrations
by Botticelli. Originally the manuscript was arranged in such a
way that the reader, on opening the book, had in front of him

on one page the text of a complete canto and on the other the drawing illustrating it.

Unfortunately the illustrations for the poem are in varying degrees of completion. Some cantos, such as *Paradiso* XXXII and XXXIII, were probably never executed, and some leaves of the codex have been lost. For those leaves still known, however, each page has at least the primary sketching in a metal stylus. These sketches are so faint that it is often difficult to discern exactly what Botticelli had intended and it is only at the second stage of execution, where the outlines were gone over with a pen and black or brown ink, that the master's concept became clear. The cohesion of each illustration and the beauty of the lines leave no doubt that the whole is by one hand.

The fact that a few of the pages have been treated with colour 94 has sparked an unending debate as to whether or not these drawings, such sensitive renderings in themselves, were originally intended to be coloured. It has been suggested that the colour was found to interfere with the subtlety of the drawings and was therefore abandoned. However, since the whole project was never completed, any such hypotheses can only be speculation. The colour, wherever applied, is extremely delicate and compatible with Botticelli's finest works.

Dante's epic had inspired illustration in Italy almost from the moment it was completed. Today there are still extant over thirty illuminated codices from the fourteenth and fifteenth centuries, the earliest of which dates back to 1337. The illumination of Dante manuscripts followed the general pattern of late medieval book illustration. Pictures were integrated into the written page, placed either in the text itself or along the margin. Such drawings could be framed in a variety of ways or simply stand unframed on the page. While it was normal for each miniature to illustrate one event only, the enormous wealth of figures and narrative in Dante's allegory suggested a second type of illustration, wherein figures are repeated to show a progression of events. But whatever method was used, the picture remained comparatively small and compact. A whole

page, text and illustrations, formed a decorative entity, sometimes enhanced by a historiated initial or an ornamental border.

Botticelli broke radically with this tradition. Each drawing fills a whole page and is completely separated from the text which now is written on the opposite page. The 'comic strip' character of previous manuscripts is completely transformed into monumental settings for each canto, and the figures range over the entire page as they move through the scene. Botticelli has, with incredible imagination, come as close as he can to giving his figures animation in a medium which only allows poses. The repetition of figures serves not simply to accommodate more incidents within one picture, but to show movement from place to place as the story progresses. The ingenuity is even more astonishing when one realizes that these are line drawings with no shading used to give dimension. Botticelli has also paid meticulous attention to the continuity of the poem so that each setting flows into the next. Very often the previous circle of Hell or Purgatory appears at the edge of the leaf.

132, 133 A fine example of this can be seen in *Purgatorio* X and XI. The sinners bearing stones on their backs come crawling in from the right, while Dante and Virgil are moving from left to right. In the next illustration Dante and Virgil move from right to left and the sinners are crawling out to the left. In this way it is shown that the sinners are crawling past Dante and Virgil while they speak to them.

Of Botticelli's always immensely impressive drawings, only a few can be discussed here, and the choice is a difficult one.

123 The drawing for the first Canto of the *Inferno* treats the central events of Dante's text. The poet is lost in a dark forest at the foot of a mountain. As he starts to climb his path is blocked by three wild beasts: a leopard, a lion, and a wolf. Virgil, sent by Beatrice, appears to the terrified poet and offers guidance.

In Botticelli's drawing Dante is seen five times. On the extreme left he walks through the forest, deep in thought. He is portrayed in the conventional Dante costume, a medieval

123 Illustration to Dante's *Inferno*, Canto I

scholar's cap and gown. The second figure is largely eradicated, but Dante's foot can be seen as he sits to rest. As he leaves the forest he is confronted by the leopard; a few steps farther on he appears again facing the lion; and finally Virgil appears as Dante turns to flee in fear from the wolf. The Roman poet is not dressed in classical garb but, in accordance with medieval tradition, as a magician in a wide cloak and oriental conical hat. In the sky Beatrice can be seen floating. The landscape is portrayed with great detail – there are even pine cones on the pine tree – and the forest recedes behind the slope of the mountain. Virgil emerges from a cleft in the rock which *125* indicates which way the path lies that the poets shall take.

It is interesting to compare Botticelli's illustration with a miniature from one of the finest illuminated codices of the *124* fifteenth century which was almost certainly written and

124 Illustration to Dante's *Inferno*, Canto I, from a Sienese codex of about 1450

illustrated in Siena, probably around 1450. Here too continuous narrative has been used. On the left Dante, in accordance with the text, is seen asleep at the edge of a dark forest. Farther to the right he is attacked by the leopard, the lion, and finally thrown to the ground by the she-wolf. Farthest to the right he meets Virgil while Beatrice hovers behind him. The stage is narrow, the figures are arranged parallel to the picture plane, and the elements of landscape are treated in a conventional manner. The miniature, with its delicate colours and vividly described incidents is still very much in the late medieval spirit and lacks the deep space in which Botticelli has set his scene. The Sienese painter tells a story in a straightforward manner while Botticelli has created the eerie atmosphere of the encounter in the forest. The feeling of space and movement is dramatically emphasized by the contrast of the tangled mass of the 'dark forest' on the left with the brightness of the open sky on the right.

In 1481 a printed edition of the *Inferno* appeared in Florence with a Neo-Platonic commentary by Cristoforo Landino and engraved illustrations for the first nineteen cantos which are generally attributed to the Florentine goldsmith and engraver, Baccio Baldini. These engravings, although rather coarse and

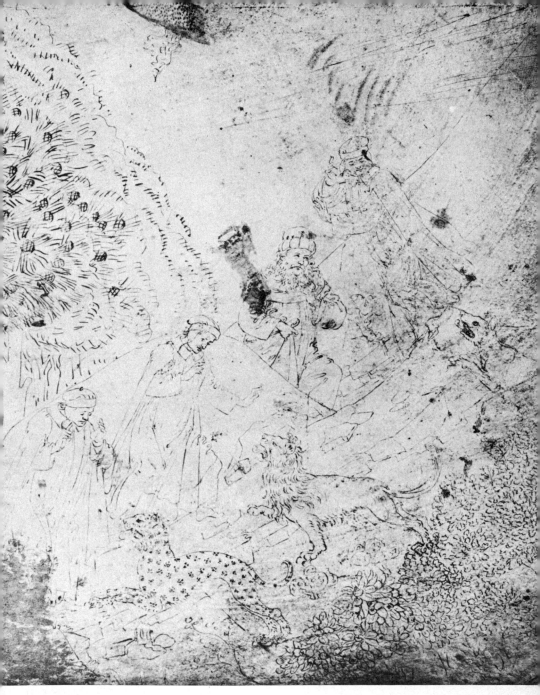

125 Detail of pl. 123

clumsy, have often been compared with Botticelli's corresponding drawings, and it has been suggested that Baldini engraved his plates with Botticelli's drawings in front of him. This, however, is impossible.

There are, no doubt, some similarities as can be seen in the *127* illustration for the first Canto. The posture of Dante as he *126* emerges from the wood on the left is almost identical. But the overall differences are more significant. For example, the movement of Dante fleeing from the beasts in no way corresponds to Botticelli's figure. More important still, Baldini's engravings are simpler in concept and composition, they have fewer figures, space is suggested rather than depicted,

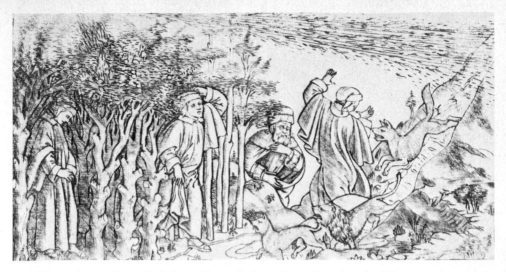

127 Illustration to Dante's *Inferno*, Canto I, from the 1481 printed edition with engravings by Baccio Baldini

and actions are less convincing than with Botticelli. Such fundamental differences are not simply due to the coarsening of designs at the hands of an inferior engraver.

To begin with, it is highly unlikely that a sumptuous Dante manuscript, lavishly illustrated for a private patron, should be given to a jobbing engraver as a pattern-book. Furthermore, the style of Botticelli's Dante drawings is incompatible with his manner about 1480. It presupposes the experience he had gained in Rome while coping with the intricate tasks of combining many scenes and figures in the Sistine Chapel frescoes. There can be little doubt that the drawings should be dated after Rome, and this assumption is perhaps confirmed by a remark of Vasari's. He calls Botticelli a man of speculative temperament who, after his return to Florence, commented on Dante and spent so much time on him that he neglected his work with the result that his affairs got into disorder. Vasari also speaks of a printed *Inferno* as a result of these endeavours, but he can hardly have had in mind the one of 1481. The origins of the Baldini engravings remain therefore hard to explain. Perhaps their models were Botticelli's first attempt at Dante illustration,

126 Detail of pl. 123

abandoned when he left for Rome. Conversely, these engravings may be the work of some artist, vaguely Botticellesque in style, whose prints Botticelli found a convenient starting-point for his own work.

94 The illustration to *Inferno* XVIII is one of the very few which have been coloured. The canto describes the first circles of the *Malebolge*, that is, the ten descending concentric stone circles, linked by bridges. In these first circles the panderers, seducers, and flatterers are punished. The task of illustrating such a complex topography was a difficult one. Earlier illustrators had been satisfied either with a schematic indication of the locality or with showing the poets encountering individual groups. Botticelli, however, has shown a monumental amphitheatre with rocky ridges separated by deep chasms and with beautifully arched bridges descending on the right.

Dante and Virgil appear six times. They walk along the top ridge, then descend across the bridges, stopping three times to look down into the abyss, and finally moving on to the lower circles. The colours used for the garments of the two poets are vivid against the brown rocks. Dante is wearing a bright pink gown over a green robe, while Virgil is clothed in blue and mauve with a bright pink conical hat. Not only do these strong colours make the protagonists stand out from the background, but they give them a brilliant contrast to the white of the damned and the rust-brown of the devils. The technique of painting is very delicate and great care has been taken to match the colours to the forms. This leaf gives the most convincing proof that Botticelli himself must have done the illumination, since drawing and painting are so cohesive they can only be by one hand.

By the side of the richness and complexity of Botticelli's page, the corresponding engraving of the 1481 edition looks primitive and inept. The *Malebolge* have been reduced to a tangle of lines with no suggestion of space or depth. The monster Geryon, which has brought Dante and Virgil down to this region, has been clumsily placed in the centre of the picture for no reason at all. Baldini has simply thrown together some of

129

186

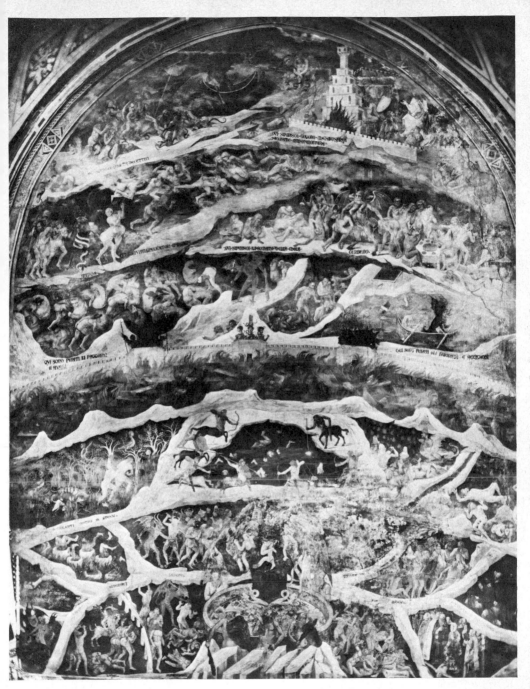

128 NARDO DI CIONE *Inferno*. Strozzi Chapel, S. Maria Novella, Florence

the figures mentioned in Dante's text but has failed to tell the story in a cohesive manner.

In his rendering of the *Malebolge* Botticelli may have been inspired by the best-known wall-painting giving a view of the whole of Dante's *Inferno*: Nardo di Cione's fresco in the Strozzi Chapel of S. Maria Novella (*c.* 1360). Nardo, of course, depicts not only the abode of the flatterers and seducers, but the idea of descending rocky circles linked by ledges is also remarkably similar.

128

The inventive manner in which Botticelli adapted his style to the ever-varying task may be seen from the illustration for *Inferno* XXXI. Dante and Virgil come upon the giants, among them Nimrod who blows his horn, standing on the edge of the central pit. As all except Antaeus are chained, Virgil asks him to lower the two poets into the next region of Hell. The scene is set among cliffs and rocks. Scale plays an important part in this drawing and the figures of Dante and Virgil, appearing four

130

129 Baccio Baldini's illustration to Dante's *Inferno*, Canto XVIII. Foi Botticelli's version see pl. 94

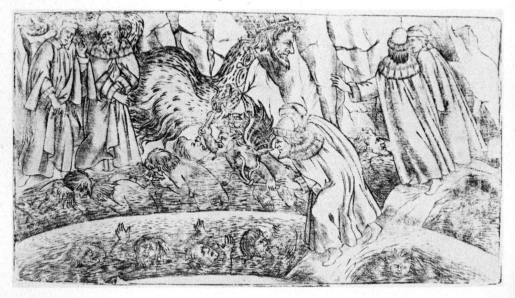

130 Illustration to Dante's *Inferno*, Canto XXXI

times, seem fragile and lost by the side of the giants tower-
ing over them. These athletic nudes, so uncharacteristic of
Botticelli, derive from the famous battle print of the early 1470s
by Antonio Pollaiuolo. This drawing is just one of the
innumerable echoes deriving from this famous pattern group.
Another significant borrowing from Antonio is the transform-
ation of the bow-setting archer of the *Martyrdom of St Sebastian*
into the giant Antaeus bending over as he hands down Dante
and his guide.

The close attention with which Botticelli studied the devices
by which Dante assured the continuity of the journey can be
seen particularly well in the illustration for Canto X of
Purgatorio. Here Dante describes how the poets pass a rock
decorated with reliefs depicting examples of humility: the
Annunciation, David dancing before the Ark, and the Justice of
Trajan.

131, 132

10

131 Illustration to *Purgatorio*, Canto X (see also pl. 132)

132 Illustration to Dante's *Purgatorio*, Canto X

After Virgil has interpreted these reliefs, he points to the proud who, bent double under heavy stones, enter in a slow procession. Botticelli has followed the poet to the letter. The gate of Purgatory is seen closing behind Dante and Virgil as they make their way up to the ledge where the three examples of humility are shown. To the extreme right the first of the proud can be seen crawling into the picture.

Botticelli's interpretation of the 'reliefs' described by Dante is particularly interesting. All three are shown not as carvings but as paintings, although the Justice of Trajan is the only one which is framed. For the Annunciation Botticelli has used one of the standard formulas for the treatment of this subject, but he has completed only the figures of Gabriel and Mary. Behind the David scene, however, a splendid Renaissance palace with arched windows, pilasters, and cornices has been sketched in

192

133 Illustration to Dante's *Purgatorio*, Canto XI (Note the continuity between this scene and the previous one)

and the scene is given great depth by continuing the architecture behind the left edge of the frame for the Trajan picture. This splendid work, the most complete of the three scenes, is strongly reminiscent of one of Paolo Uccello's *Battle of San Romano* panels with its hilly scenery, crowd of horsemen and foot-soldiers, and a forest of lances. Botticelli has even included a triumphal arch to add to the authenticity of the setting.

In the eleventh Canto Dante and Virgil encounter those who *133* are punished for their pride by carrying heavy stones. The poet and his guide are seen three times: approaching the procession of sinners from the right, walking beside it while Virgil asks the way, and finally Dante bending down to speak to a man doubled up under the weight of his stone. Although the scene is unfinished the drawing is so skilful that there is no need for any complex background. In fact, the austerity makes it more

134 Illustration to Dante's *Paradiso*, Canto I

effective than some of the overcrowded scenes. One of the most brilliant touches is the figure of Dante leaning over and peering at the face under the rock.

This particular scene must have been of special interest to Botticelli. The man with whom Dante speaks is Oderisio da Gubbio, who had been famous as a painter of miniatures. He lectures Dante on the vanity of pride and earthly fame, reminding him that, in a previous generation, Cimabue had been the most renowned of painters but that now his place had been taken by Giotto. When Botticelli found his fame outstripped by Leonardo and Michelangelo in the 1490s, he must have thought of this passage with particular poignancy.

Just as Dante changes from a dramatic and often savagely cruel narrative when he enters the *Paradiso*, so too does Botticelli radically alter the manner of his representation.

Punishment and penance are replaced by long passages of theological and lyrical contemplation and, while narrative was a common enough genre of painting in the fifteenth century, the portrayal of the effects of vision on the visionary was an entirely new venture.

At the beginning of Canto I of the *Paradiso*, Dante implores the aid of Apollo for his poem. Dante sees the sun and Beatrice and, as he looks at her, he hears the music of the spheres and sees a great aura of pure light. Beatrice explains to him that he is flying upward by the will of God. Earlier illustrators depicted Dante and Beatrice standing on solid ground, but Botticelli has concentrated on the last episode of the Canto: the upward journey. The most telling device is Botticelli's use of repeated circular forms. The rivers form a circle, the horizon follows their line, the trees bend gently, and the two figures rise diagonally towards the perfect circle of the first sphere. `134`

In showing the journey through the spheres Botticelli makes use of just this device. Each drawing shows Dante with Beatrice floating within a circle. Although many of the illustrations are unfinished, there is no doubt that Beatrice and Dante never touch anything solid and that no illustration of the allegorical stories told by Beatrice, on which earlier illustrators had relied, seems to have been intended. All is pure vision.

When Beatrice and Dante reach the Heaven of the Fixed Stars in Canto XXVI, they stand on top of the last sphere. Dante is blinded by the brilliant light emanating from the saints and covers his eyes with his hand while Beatrice points upward to the nine Heavenly spheres, indicated by flames in concentric circles with the Godhead in the middle. Botticelli has not only attempted to show the visionary quality by these dynamic circles of flame, but has also followed Dante by having the saints remain as flames identified only by their names. No previous illustrator had had the courage to depend on so literal a representation, preferring to show actual personifications of the saints. Beatrice is here, as in all the illustrations, noticeably larger than Dante. This change in scale is at variance with Renaissance `135` `137`

135 Illustration to Dante's *Paradiso*, Canto XXVI

practice but in this case it is perhaps a not surprising revival of a medieval convention according to which the theologically most significant figure was distinguished by size.

Unfortunately Botticelli never illustrated the last two cantos of the *Paradiso*. He did, however, sign his work in the illustration for *Paradiso* XXVIII, the Nine Hierarchies of Angels. In the lowest circle of angels, who hold the names of those who hope to go to heaven, 'Sandro di Mariano' is inscribed in tiny letters.

The depth of feeling with which Botticelli would have portrayed the prayer of St Bernard can be perhaps hinted at in
136 his illustration for Canto XXX, the arrival in the highest heaven. Botticelli has chosen to illustrate the moment when
138 Dante sees the heavenly light as a shining river flowing between banks decked out with flowers. Beatrice, her arm pointing forward and upward, leads him towards the source of light. The

196

136 Illustration to Dante's *Paradiso*, Canto XXX

drawing is incomplete, but the flowers on the left bank are drawn with great delicacy and imagination, for these are no earthly flowers. The jewel-like sparks that Dante describes rising from the river and falling back in, intoxicated by the smell of the flowers, are shown, as had been done in earlier works, as little putti tumbling about with great abandon.

The Dante drawings must surely be counted among Botticelli's greatest works. In spite of their comparatively small size they can rank with the Sistina frescoes for the complete mastery of narrative, faultless technique, and powerful imagination. Unique in their conception and unparalleled in their execution, they are at once self-sufficient drawings and vivid pictorial accounts of an unusually complex text. It is useless to speculate whether a completely coloured set of illuminations would have been more effective. It is remarkable what Botticelli achieved with the pen alone.

197

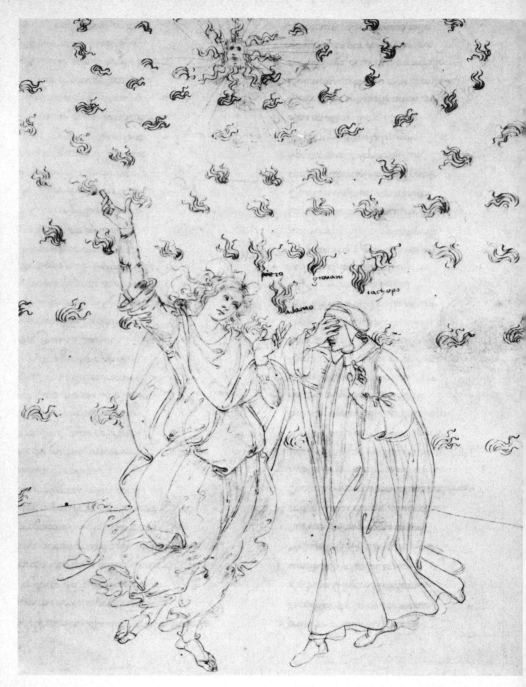

137 Beatrice shows Dante the Nine Hierarchies of Angels (detail of pl. 135)

Conclusion

OF ALL QUATTROCENTO PAINTERS Botticelli is probably the most exclusively Florentine. He was born in the city and received his training there though as a young man he may have assisted his master Filippo Lippi with the frescoes in the choir of the cathedral at Spoleto. At a later date he made an abortive attempt to obtain a commission in Pisa. But after he returned from Rome, having taken part in the decoration of the Sistine Chapel, he never left Florence again and we know of no commission which might have tempted him away. This must seem strange since artists of the fifteenth century were highly mobile and the activities of many extended over large areas of the peninsula.

Yet the call to Rome gives evidence that Botticelli's fame had spread and the fact that he avoided further travelling must surely have psychological reasons. A man who never established his own home but preferred throughout his life to share a house with members of his family was unlikely to seek employment abroad. The antiquities of Rome, so stimulating to others, seem to have held little attraction for him. In fact, throughout his art we can notice a marked lack of curiosity which is unusual in a Florentine. There is no exploration of the human form, and his interest in Antonio Pollaiuolo's anatomical observations was short-lived. There is no nature study, as Leonardo da Vinci himself pointed out scornfully, and none of Sandro's surviving drawings are concerned with investigations of form or composition.

It is not easy to establish Botticelli's place within the tradition of Florentine painting. He remained highly individual all his life, yet he showed awareness of past and contemporary art. The *Fortitude* of 1470, as well as some of his later works, has obvious 6

features reminding us of Filippo Lippi, but the picture is certainly not a 'school' work in the narrow sense of the word. While there is less concern with solidity and the placing of the figure in space, there is also less realism than in the pictures of his teacher. Instead there is an interest in careful modelling, particularly of the face, in the linear interplay of draperies, and most of all in the body movement suggested by these draperies. All these must come from acquaintance with the work of Verrocchio and Pollaiuolo.

26 The Uffizi *Adoration* of the late 1470s, a painting which superficially seems to demonstrate every achievement of Florentine fifteenth-century art, shows how much Botticelli departs from normal practice. He has learned to construct the pictorial space for so elaborate a scene and his handling of perspective is secure. But this can hardly have been his preoccupation. His stage is crowded and narrow with none of that airy spaciousness which we find for example in his

29 contemporary, Ghirlandaio. The San Martino *Annunciation* shows the same irrational treatment of space even more strikingly. The house and garden of the Virgin are beautifully shown but the gigantic fast-moving angel, and the swaying, fragile figure of the Virgin are neither drawn to the same scale nor are they placed within this setting. A picture with this ambiguity recalls traditions of Trecento painting and the methods employed by Ghiberti on the Porta del Paradiso of the Florentine Baptistery or Fra Angelico in the wall-paintings for the cells of San Marco. Whatever Botticelli learned from the Masaccio tradition, he was more deeply impressed by the continuing tradition of International Gothic. Yet he was always more vigorous, more firm in his statements than, say, Benozzo Gozzoli.

 The strength of paintings like the San Martino *Annunciation*

15 or the *St Augustine* of Ognissanti justify the characterization of Botticelli's art given by the Milanese agent in Florence when he wrote to Lodovico Sforza of its 'virile air' to which he juxtaposed the 'sweeter' manner of Perugino and Filippino

Lippi. This assessment is so telling precisely because it does not use critical jargon but gives a spontaneous response to the art of three leading painters. It is of course not the virility of Antonio Pollaiuolo's powerful and muscular supermen which gives Botticelli's pictures their strength, but the logic of his compositions and their linear rhythm. They are dramatic where Filippino and Perugino are lyrical.

Most enlightening in determining Botticelli's place in the art of his age are surely the frescoes of the Sistine Chapel, since they can be compared most easily with the work of the masters who worked alongside him. With the exception of Perugino, none of the others measure up to Sandro, though their styles had – as to be expected – many elements in common. Rosselli, the weakest of the painters called to Rome, gives a mechanically correct rendering of the incidents he has to depict, but his figures are ill-proportioned and awkward, his compositions are dull and his landscapes lifeless. Ghirlandaio, his massive figures well displayed in space, their actions clearly stated and each head highly individualized, represents a tradition which goes back to Masaccio. But it has become much tamer. It is an easy-going, somewhat prosaic way in which he tells his stories, and even in highly dramatic incidents, such as the *Calling of the First Apostles*, no real tension is felt. Perugino has full mastery over all fifteenth-century innovations: perspective, proportion, the human figure in motion, and a clear narrative technique. Yet his lack of temperament robs even his finest frescoes – such as *Christ's Charge to St Peter* – of their full potential. The groups behind Christ and St Peter are as dignified as the occasion requires, but they are also dull, monotonously identical in scale and arranged in a single row. The two small subsidiary scenes in the middle ground – the illustration of Christ's command 'Render unto Caesar' on the left, and the attempt to stone Christ on the right – are too small in scale to be effective.

Botticelli, lacking none of the skills of his colleagues, uses them to greater advantage. More sensitive to the demands of his

tasks, he executed his frescoes with greater artistic intelligence. This becomes most apparent in the way in which he combines several incidents within one frame. Each one is treated as part of a story, and all parts are of equal importance. The clarity of depiction is more important to him than a display of Quattrocento achievements, and hence his frescoes appear much more individual, although they share a common artistic language with the others.

As one might expect, the stay in Rome had a profound effect on Botticelli. He must have been deeply impressed by the scale and grandeur of what he encountered in Rome and the monumentality which is apparent during the next ten years must be a result of this. Yet in a significant way Botticelli's reactions differed from those of his contemporaries. He seems to have taken little interest in borrowing from classical statuary or reliefs and in the frescoes of the Sistine Chapel there occurs only one – and that verbatim – classical quotation: the triumphal

3 arch of the Corah fresco, an accurate transcription of the Arch of Constantine. Other artists filled their sketchbooks with drawings after the antique. We still have from Ghirlandaio's workshop such a sketchbook with careful renderings of all kinds of antique art, and echoes – or copies – from the antique are ubiquitous in late fifteenth-century painting. But nothing of the kind ever happens with Botticelli. His predilection for line maybe precluded him from a real appreciation of classical

90 sculpture. The Venus, of the *Birth of Venus*, could have been painted by somebody who had never seen a piece of antique

96 sculpture, and the *Calumny of Apelles* which is, after all, a reconstruction of a Greek painting, relies on a classical text and a literary tradition, but not on visual sources from ancient art.

As far as Botticelli was concerned the antique was not a model to be followed slavishly. It stimulated his imagination, but it did not provide him with a new vocabulary. We are left with a striking paradox: the first Renaissance painter of large classical allegories painted them in an idiom which was less

classicizing than those employed in religious paintings by, say, Ghirlandaio or Filippino Lippi.

It is hardly surprising that Botticelli lost his appeal during the last years of his life. He never shared the Quattrocento's preoccupation with perspective, his space remaining narrow right to the end. More important still, Sandro's line is always taut and descriptive with none of the painterly values or the chiaroscuro (subtle gradations of light and shade to convey modelling) introduced by Leonardo and taken up by Fra Bartolomeo and others. The human form never became the central purpose of his art, as it was in that of the young Michelangelo. At the very moment in the 1490s when, through Leonardo and later Michelangelo, a new monumentality began to dominate Florentine art, it disappeared from Botticelli's painting. Even the two *Lamentations*, in spite of their expressive intensity, are on a comparatively small scale. By about 1500 Botticelli's art must have seemed old-fashioned. He was still respected because in 1504 he was put on the committee which had to decide about a site for Michelangelo's *David*. But one cannot help wondering what he thought of a piece of sculpture which must have been utterly alien to him.

60, 62

When Vasari published his *Lives* in 1550, he gave Botticelli his due, even expanding both the biography and list of works in the 1568 edition. In the light of the material available to him he wrote a good and balanced account, and his attributions (even where wrong) are a good deal more responsible than those of some celebrated modern scholars. He was clearly ill at ease with Sandro and did not know how to fit him into his evolutionary scheme of the history of art running from Cimabue to Michelangelo. But this is to Vasari's credit. Here again the sensitive historian-painter was right when he recognized that Botticelli was an outsider in the mainstream of Italian painting between the fourteenth and the sixteenth centuries.

The uniqueness of Botticelli's art did not endear him to the following centuries when academic art reigned supreme and such artists as Guido Reni and Correggio competed for highest

standing in the popular taste. His most prominent works, the Sistine Chapel frescoes, were overpowered by the work of Michelangelo which, while not always exciting admiration in sightseers, certainly left them awestruck. Sandro's other works remained hidden away in Tuscan churches and private houses, unseen by the tourist and unmentioned in guidebooks. For some 250 years these works were neglected and often disposed of to make room for something more 'modern'.

The anti-academic movement of the early nineteenth century did not turn to Botticelli either. In rejecting one concept of beauty it had substituted another into which Botticelli again could not be fitted. His large, elongated forms, his nervous line and his melancholic faces pleased neither the more traditional-minded traveller nor the intellectual seeking a 'purer' art. It is interesting that, although it hung in the Uffizi after 1815, the *Birth of Venus* received little, if any, notice in travellers' accounts of the 1820s or 1830s, while the *Medici Venus*, Canova's *Venus* and Titian's *Venus* all receive ample comment.

It was not until after 1850 that a taste for Botticelli's art began to percolate down to the popular level. Although as early as 1799 William Young Ottley, an English collector, had bought the *Mystic Nativity*, he was a man of unique taste for the period. When he offered the picture for sale in 1811, he could not find a buyer. The French invasion of Italy had forced many previously wealthy families to sell their collections and hitherto unknown paintings began to appear on the market. The Berlin Gallery acquired its first Botticelli – the *Bardi Altarpiece* – in 1829, but the London National Gallery followed only in 1855, buying a *Madonna* now generally regarded as a workshop piece. By that time the name of Botticelli had become increasingly familiar, but not his style. A variety of pictures, even some Trecento works, were ascribed to the master, while many of the works attributed to him today were assigned to other painters, among these the portrait of a young man now in the National Gallery, London.

It has been claimed that the Pre-Raphaelite Brotherhood rediscovered Botticelli for the English-speaking world, and in a way this is true. When the original Brotherhood in 1848 drew up their famous list of 'Immortals' (beginning with Jesus Christ) they included only two Quattrocento artists: Ghiberti and Fra Angelico. But individually the artists of the group began to discover Botticelli on their own. The *Coronation of the Virgin* *44* made a tremendous impression on Burne-Jones when he saw it in 1859. Botticelli was Millais' favourite painter when he was in Florence in 1865. William Michael Rossetti was enthusiastic over the *Birth of Venus* after his return from Florence in 1860, *88* and Dante Gabriel Rossetti bought what was then thought to be a Botticelli portrait in 1867. Perhaps most important was the review of the collection of drawings in the Uffizi by Swinburne in 1868, for this inspired the greatest aesthetic appreciation of Botticelli, the essay by Walter Pater, first published in 1870 and later embodied in *The Renaissance*. In poetic language Pater outlined the profile of the painter which has dominated the concept of Botticelli for so long that it still haunts the more popular literature. It is the image of an artist of a slightly melancholic cast of mind, of a man torn between traditional Christianity and a new Renaissance paganism.

We know today that Pater was wrong, both in his assessment of Botticelli's personality and in his characterization of the Renaissance. Nevertheless this beautifully written essay is something of a work of art in its own right and it inspired generations of readers to look at Botticelli's pictures. It should be emphasized that the one outstanding monograph on Botticelli, Horne's book of 1908, is dedicated to Walter Pater.

It is largely due to Herbert Horne that today we can see Botticelli and his art in a proper historical context. Collecting every scrap of evidence from documents and early sources he studied everything attributed to Botticelli and with rare sensitivity separated the wheat from the chaff. Very little of his book has been proved wrong, and it remains one of the most stupendous achievements in Renaissance studies.

In recent years iconological studies of Botticelli's secular works in particular have become the fashion, and together with Michelangelo and Raphael he has become one of those masters whose art allegedly hides more than it reveals. While it is of course true that some of these investigations have told us something of value about Botticelli, and in particular about his relationship with his patrons, others unfortunately have buried some of the most sensitive paintings ever made under a mountain of esoteric, and often irrelevant, learning.

Just over a hundred years ago Pater asked himself whether 'a secondary painter' like Botticelli could 'be a proper subject for general criticism'. He was thinking, of course, in purely aesthetic terms, but in answering this hypothetical question in the affirmative he added a general observation which we can still apply to Botticelli although we are now as much concerned with the form as with the content of his art. 'In studying his work', Pater wrote right at the end of his essay, 'one begins to understand to how great a place in human culture the art of Italy had been called.'

138 Beatrice leads Dante towards the light of heaven (detail of pl. 136)

Bibliography

The bibliography lists only a few books and articles which the authors feel may be of help in a further study of Botticelli. Many of the publications which have made important contributions to the discussion of Botticelli are in foreign languages and therefore, with two exceptions, not listed.

MONOGRAPHS

Clark, Kenneth, *The Drawings by Sandro Botticelli for Dante's Divine Comedy*, London, 1976. A complete reproduction of all the surviving drawings in Berlin and the Vatican, with a critical and explanatory text.

Horne, Herbert P., *Alessandro Filipepi, called Sandro Botticelli*, London, 1908. Horne's monograph will always remain one of the greatest achievements of art historical writing. It is the fruit of meticulous research, deep feeling for the art of Botticelli, and an astounding amount of common sense. Unfortunately, the book was published in a limited edition so that it is hard to find.

Lippman, F., *Die Zeichnungen von Sandro Botticelli zu Dante's Göttliche Komödie*, 1886; second edition, 1896. An old publication which was the first to provide facsimiles of the Dante drawings.

Mesnil, Jacques, *Botticelli*, Paris, 1938. A sensitive and well documented account in French.

Pope-Hennessy, Sir John, *The Mystic Nativity*. A careful analysis of the style and historical context of the picture in the London National Gallery.

Salvini, Roberto, *All the Paintings of Botticelli*, London, 1965. A thorough record of Botticelli's œuvre. On the whole, the author is catholic about attributions and his appendix dealing with those he does not accept is very useful. All works are illustrated.

GENERAL

Berenson, Bernard, *The Drawings of the Florentine Painters*, 1903; second edition, 1938. Berenson lists and briefly discusses the drawings of Botticelli although the sensitivity of the Dante illustrations eludes his grasp.

Ettlinger, L.D., *The Sistine Chapel before Michelangelo: Religious Imagery and Papal Politics*, Oxford, 1965. A brief discussion of the Sistina frescoes.

Vasari, Giorgio, *Lives of the Painters*, available in several English translations, has a worthwhile if brief account of the painter's life.

HISTORY

Brucker, Gene, *Renaissance Florence*, New York, 1969. An excellent general history of Florence.

Weinstein, Donald, *Savonarola and Florence: Prophecy and Patriotism in the Renaissance*, Princeton, 1970. The best account of Savonarola's impact on Florence.

ARTICLES

Gombrich, Sir Ernst H., 'Botticelli's Mythologies: A Study in the Neo-Platonic Symbolism of his Circle', reprinted in *Symbolic Images: Studies in the Art of the Renaissance*, London, 1972. An important, though controversial, account of Botticelli's possible links with Neo-Platonism. The article also contains a full bibliography of literature on the *Primavera* up to 1972.

Levey, Michael, 'Botticelli and Nineteenth Century England', *Journal of the Warburg and Courtauld Institutes*, XXIII, pp. 291–306. Discusses the re-discovery of Botticelli.

Salvini, Roberto, 'Botticelli', *Encyclopedia of World Art*, 1960. An excellent summary of essential information with an extensive bibliography.

List of Illustrations

Dimensions are given in inches and centimetres, height preceding width

1 *Primavera* (detail)
Panel
Uffizi, Florence

2 *St Augustine in his Study* (detail)
Fresco
Ognissanti, Florence

3 *The Punishment of Corah* (detail)
Fresco
Sistine Chapel, Rome

4 *Fortitude* (detail)
Panel
Uffizi, Florence

5 PIERO POLLAIUOLO (1443–96)
Temperance 1470
Panel $65\frac{3}{4} \times 34\frac{5}{8}$ (167 × 88)
Uffizi, Florence

6 *Fortitude*
Panel $65\frac{3}{4} \times 34\frac{1}{4}$ (167 × 87)
Uffizi, Florence

7 ANTONIO (*c.* 1432–98) and PIERO
POLLAIUOLO
Martyrdom of St Sebastian (detail)
Panel
National Gallery, London

8 *St Sebastian*
Panel $76\frac{1}{4} \times 29\frac{1}{2}$ (195 × 75)
Staatliche Museen Preussischer Kulturbesitz, Berlin

9 *St Sebastian* (detail)

10 *The Finding of the Body of Holofernes*
Panel $12\frac{1}{4} \times 9\frac{7}{8}$ (31 × 25)
Uffizi, Florence

11 *Judith and her Maid*
Panel $12\frac{1}{4} \times 9\frac{1}{2}$ (31 × 24)
Uffizi, Florence

12 ROGIER VAN DER WEYDEN
(1399/1400–64)
Entombment c. 1450
Panel $43\frac{1}{4} \times 37\frac{3}{4}$ (110 × 96)
Uffizi, Florence

13 DOMENICO GHIRLANDAIO (1449–94)
St Jerome
Fresco
Ognissanti, Florence

14 JAN VAN EYCK (*c.* 1390–1441) and
PETRUS CHRISTUS (*c.* 1400–72?)
St Jerome
Panel $7\frac{7}{8} \times 5\frac{1}{8}$ (20 × 13)
Courtesy of the Detroit Institute of Arts

15 *St Augustine in his Study*
Fresco $59\frac{7}{8} \times 44\frac{1}{8}$ (152 × 112)
Ognissanti, Florence

16 FRA ANGELICO (*c.* 1387–1455) and FRA
FILIPPO LIPPI (1406–69)
Adoration of the Magi c. 1445
Panel, diam. 54 (137·2)
National Gallery of Art, Washington
DC. Samuel H. Kress Collection

17 GENTILE DA FABRIANO (*c.* 1370–1427)
Adoration of the Magi 1423
Panel
Uffizi, Florence

18 *Adoration of the Magi*
Panel $19\frac{3}{4} \times 53\frac{1}{2}$ (50 × 136)
National Gallery, London

19 *Adoration of the Magi* (detail)
Panel
National Gallery, London

20 *Adoration of the Magi* (detail)
Panel
National Gallery, London

21 *Adoration of the Magi* (tondo)
Panel diam. $51\frac{1}{2}$ (131·5)
National Gallery, London

22 *Adoration of the Magi* (tondo detail)
Panel
National Gallery, London

23 *Adoration of the Magi* (tondo detail)
Panel
National Gallery, London

24 Medal of Cosimo il Vecchio 1464
By courtesy of the Trustees of the British
Museum

25 MINO DA FIESOLE (c. 1430–84)
Bust of Piero de' Medici 1453
Bargello, Florence

26 *Adoration of the Magi*
Panel 43¾ × 52¾ (111 × 134)
Uffizi, Florence

27 LEONARDO DA VINCI (1459–1519)
Adoration of the Magi
Panel 95⅝ × 96⅞ (243 × 246)
Uffizi, Florence

28 *Adoration of the Magi*
Panel 27½ × 40¾ (70 × 103·5)
National Gallery of Art, Washington
DC. Mellon Collection

29 *Annunciation*
Fresco 95⅝ × 216½ (243 × 550)
Uffizi, Florence

30 *The Youth of Moses*
Fresco 137¼ × 219⅝ (348·5 × 558)
Sistine Chapel, Rome

31 *The Punishment of Corah*
Fresco 137¼ × 224⅜ (348·5 × 570)
Sistine Chapel, Rome

32 *The Youth of Moses* (detail)
Fresco
Sistine Chapel, Rome

33 *The Temptation of Christ* (detail)
Fresco
Sistine Chapel, Rome

34 *The Temptation of Christ*
Fresco 136 × 218½ (345·5 × 555)
Sistine Chapel, Rome

35 *The Temptation of Christ* (detail)
Fresco
Sistine Chapel, Rome

36 *The Temptation of Christ* (detail)
Fresco
Sistine Chapel, Rome

37 *The Temptation of Christ* (detail)
Fresco
Sistine Chapel, Rome

38 *Virgin and Child with Saints (S. Barnaba
Altarpiece)*
Panel 110¼ × 105½ (280 × 268)
Uffizi, Florence

39 *Virgin and Child with Saints (S. Barnaba
Altarpiece)* (detail)
Panel
Uffizi, Florence

40 *Virgin and Child with Saints (S. Barnaba
Altarpiece)* (detail)
Panel
Uffizi, Florence

41 *The Mystic Nativity* 1500
Canvas 42¾ × 29½ (108·5 × 75)
National Gallery, London

42 *The Mystic Crucifixion (Magdalene at the
Foot of the Cross)*
Canvas 28½ × 20¼ (72·3 × 51·3)
Courtesy of the Fogg Art Museum,
Harvard University. Gift – Friends of
the Fogg Art Museum

43 *Virgin and Child with Saints (Bardi
Altarpiece)*
Panel 72⅞ × 75 (180 × 185)
Gemäldegalerie, Staatliche Museen
Preussischer Kulturbesitz, Berlin

44 *Coronation of the Virgin*
Panel 47¼ × 25⅝ (120 × 65)
Uffizi, Florence

45 FRA ANGELICO (c. 1387–1455)
Coronation of the Virgin 1430–5
Panel 44⅞ × 44½ (114 × 113)
Uffizi, Florence

46 *Coronation of the Virgin* (detail)
Panel
Uffizi, Florence

47 *Coronation of the Virgin* (detail)
Panel
Uffizi, Florence

48 *Annunciation*
Panel 59 × 61⅜ (150 × 156)
Uffizi, Florence

49 *Madonna of the Magnificat*
Panel diam. 46½ (118)
Uffizi, Florence

50 *Madonna of the Magnificat* (detail)
Panel
Uffizi, Florence

51 *Madonna of the Magnificat* (detail)
Panel
Uffizi, Florence

211

128 NARDO DI CIONE (*fl.* 1343–65)
Inferno
Fresco
Strozzi Chapel, S. Maria Novella,
Florence

129 BACCIO BALDINI
Engraved illustration to Dante's *Inferno*,
Canto XVIII, from Cristoforo Landino:
*Comento di Christophoro Landino Fioren-
tino Sopra la Comedia di Danthe Alighieri
poeta Fiorentina*, Florence, 1481

130 Illustration to Dante's *Inferno*, Canto
XXXI
Drawing (silverpoint, ink on vellum)
$12\frac{5}{8} \times 18\frac{1}{2}$ (32×47)
Kupferstichkabinett, Staatliche Museen
Preussischer Kulturbesitz, Berlin

131 Illustration to Dante's *Purgatorio*, Canto
X (enlargement)
Drawing (silverpoint, ink on vellum)
$12\frac{5}{8} \times 18\frac{1}{2}$ (32×47)
Kupferstichkabinett, Staatliche Museen
zu Berlin

132 Illustration to Dante's *Purgatorio*, Canto
X
Drawing (silverpoint, ink on vellum)
$12\frac{5}{8} \times 18\frac{1}{2}$ (32×47)
Kupferstichkabinett, Staatliche Museen
zu Berlin

133 Illustration to Dante's *Purgatorio*, Canto
XI

Drawing (silverpoint, ink on vellum)
$12\frac{5}{8} \times 18\frac{1}{2}$ (32×47)
Kupferstichkabinett, Staatliche Museen
zu Berlin

134 Illustration to Dante's *Paradiso*, Canto I
Drawing (silverpoint, ink on vellum)
$12\frac{5}{8} \times 18\frac{1}{2}$ (32×47)
Kupferstichkabinett, Staatliche Museen
zu Berlin

135 Illustration to Dante's *Paradiso*, Canto
XXVI
Drawing (silverpoint, ink on vellum)
$12\frac{5}{8} \times 18\frac{1}{2}$ (32×47)
Kupferstichkabinett, Staatliche Museen
zu Berlin

136 Illustration to Dante's *Paradiso*, Canto
XXX
Drawing (silverpoint, ink on vellum)
$12\frac{5}{8} \times 18\frac{1}{2}$ (32×47)
Kupferstichkabinett, Staatliche Museen
zu Berlin

137 Illustration to Dante's *Paradiso*, Canto
XXVI (detail)
Drawing (silverpoint, ink on vellum)
Kupferstichkabinett, Staatliche Museen
zu Berlin

138 Illustration to Dante's *Paradiso*, Canto
XXX (detail)
Drawing (silverpoint, ink on vellum)
Kupferstichkabinett, Staatliche Museen
zu Berlin

PHOTOGRAPHIC ACKNOWLEDGMENTS

Alinari 45, 47; Anderson 110, 111; Bayerische
Staatsgemäldesammlungen, Munich 60; Bul-
loz 99, 100, 101; Mansell-Alinari 1, 5, 13, 17,
25, 39, 40, 48, 55, 61, 81, 83, 89, 90, 98, 103,
104, 105, 108, 109, 112, 113, 114, 128;
Mansell-Anderson 6, 10, 32, 34, 35, 37, 49, 50,
51, 54, 57, 74, 87, 96, 97, 118, 119; Mansell-
Brogi 2, 4, 56, 121, 122; Mansell Collection
44; Mas 75, 76, 77; Scala 11, 28, 29, 30, 31, 33,
36, 38, 82, 86